IMAGES
of America

INDEPENDENCE

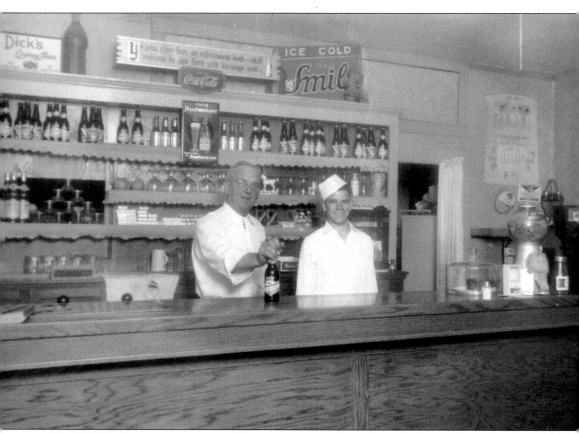

Linville's Barbecue was a popular drive-in restaurant located on Highway 40 on the south side of Independence in the 1930s. Charlie Linville (left) stands next to Loyd Stephenson, one of the store's carhops, in this photograph taken in 1933. Stephenson and his twin brother, Les, also a Linville carhop, went on to build the very successful Stephenson's Apple Farm Restaurant. (Wanda Stephenson.)

On the cover: The Katz Drug Company, on the northeast corner of the Independence town square, was a popular store in this 1950 photograph. The store sold everything from patent medicines to pet monkeys at cut-rate prices and was known for its catchy advertising slogans and the bold, black cat head symbol over the store's main entrance. The Katz chain had 65 stores in seven states when it was sold in 1971 to the Skaggs Drug Company, which later became Osco Drugs in 1984. (Harry S. Truman Library.)

INDEPENDENCE

Richard N. Piland and Marietta Wilson Boenker

ARCADIA
PUBLISHING

Copyright © 2008 by Richard N. Piland and Marietta Wilson Boenker
ISBN 978-0-7385-5219-4

Published by Arcadia Publishing
Charleston SC, Chicago IL, Portsmouth NH, San Francisco CA

Printed in the United States of America

Library of Congress Catalog Card Number: 2007941899

For all general information contact Arcadia Publishing at:
Telephone 843-853-2070
Fax 843-853-0044
E-mail sales@arcadiapublishing.com
For customer service and orders:
Toll-Free 1-888-313-2665

Visit us on the Internet at www.arcadiapublishing.com

CONTENTS

ACKNOWLEDGMENTS

The creation of this book required the cooperation and generosity of many different people. We would like to thank them for allowing us into their homes and offices to scan their collections of photographs and discuss the history of what they depicted. Their kindness, hospitality, and support for the project are greatly appreciated.

We first must thank Pauline Testerman, audiovisual archivist at the Harry S. Truman Library, for giving us unlimited access to the library's vast photograph collection. Staff members Liz Safly, Randy Sowell, and Erica Flanagan were enormously helpful in locating the images we wanted and always had a smile and encouraging word. Quite simply, this book would not have been possible without the participation of the Harry S. Truman Library.

Special thanks go to Emily Braton of the Independence Chamber of Commerce and Rick Webb of the Independence 76 Fire Company Historical Society for the opportunity to scan the excellent collection of vintage photographs owned by their organizations. We also thank Lenore Weeks for allowing us to scan her wonderful collection of pictures of the many building projects in Independence undertaken by her family's construction company.

We would also like to thank the following for the photographs they contributed to the book: Joe Antoine, Diane Baldwin, Cliff Braden, Roxanne Warr Brennan, Dianne Brungardt, Gary Christina, Fr. Michael Coleman, Sue Crumpton, Bill Curtis, Norma Wilson Frazier, Joe Gall, Mary Charlotte Gamel, Jim Graham, Nancy Adlard Hansen, Kay Fox Hazelbaker, Jan Hicks Huntsinger, Henrietta Jaques, Joe Klein, Bill Latta, Stan Link, John Malone, Yvonne Patterson, Bob Potter, Jo Bennett Reimal, Bill Roberts, Carolyn Colovin Roedel, Marvin Sands, Nancy Heckert Smith, Wanda Stephenson, Elizabeth Streich, Marilyn Kilpatrick West, Bob Williams, Joe Williams, and Jodi Wynn. We regret we could not use all the images we were offered.

Several people gave us wonderful encouragement for our work. We greatly appreciate the friendly support provided by Nina Anders, Al Carlisle, Marty Cavanah, David W. Jackson, Randy McNutt, Ronald Romig, and Wendy Shay. We want to thank Anna Wilson at Arcadia for taking our project under her wing. She always provided continued support and inspiration.

We also need to acknowledge the unquestioned support and understanding of our spouses. Marcy Piland and Kurt Boenker were always behind the project and gave us constant encouragement. They make our lives better.

Finally, Independence is our hometown. We grew up here, attended local schools and churches, worked in local businesses, have had hundreds of wonderful friends, and remember our life here with enormous pleasure, fond memories, and great pride. Thank you to all who made this town such a memorable place.

INTRODUCTION

Since its founding in 1827, Independence has been an important center of activity, and the city's past reveals a great contribution to the development of the nation. The city has evolved from being the last stop on the western edge of civilization to an agricultural center and seat of justice for Jackson County to the internationally known hometown of Pres. Harry S. Truman and the world headquarters of the Community of Christ church.

The Missouri General Assembly created Jackson County in 1826, five years after Missouri was admitted to the Union as a slave-holding state. The county was named after Andrew Jackson three years before he was elected president. Independence was designated the Jackson County seat in 1827, a distinction it still holds. The town was said to have been named after Jackson's chief quality, his independence of character.

By March 1827, David Ward, Julius Emmons, and John Bartleson had laid out the town; George W. Rhodes platted the new community. During July 1827, the 143 original lots were offered at auction by the county court. Only 73 lots were sold, with prices ranging from $6.64 to $49.72. A total of $1,124.39 was paid. Several buyers purchased two or more lots.

Most of the earliest residents of Independence immigrated from Kentucky, Tennessee, and Virginia. A log courthouse and jail were among the first structures. Soon log houses, stores, blacksmith shops, saloons, and hotels clustered among the trees and small clearings around the courthouse. Much of the land outside town was given over to farms, pastures, and orchards. In a short time, the town became the market, post office, and trading post for area farmers.

In 1830, members of the Church of Christ arrived from Ohio to begin work to convert Native Americans to their faith. Joseph Smith, the leader of the church, arrived in 1831 and declared the town to be the site of Zion, God's city on earth and the New Jerusalem. On August 3, 1831, Smith dedicated the temple lot where the members were to build a great church. In less than three years, almost 2,000 church members immigrated to Independence from New York and Ohio. They established an industrious colony with a newspaper, schools, shops, and homes.

Local residents did not accept the church members or their anti-slavery views. Agitated citizens drove the Mormons out of the county in 1833. After the church was expelled from Missouri, Smith was killed by a mob in Illinois in 1844 and the Church of Christ split into several denominations. In 1873, the group headed by Joseph Smith III returned to Independence as the Reorganized Church of Jesus Christ of Latter Day Saints (RLDS) and established their world headquarters near the original Temple Lot.

Between the 1830s and 1850s, more than a quarter million people headed west over the Santa Fe, Oregon, and California Trails; for many, Independence was the starting point. Before 1821, trade with Santa Fe, Mexico, was illegal. After Mexico won its independence from Spain, the United States government encouraged merchants to enter the markets in the southwest. In 1831, most of the caravans headed toward Santa Fe were outfitted in Independence. During the 1840s, travelers began outfitting their wagons for trips to Oregon and the California gold fields.

Interests in Independence controlled the first regular federal mail delivery contracts to the west. David Waldo, Jacob Hale, and William McCoy had the first contract to carry mail to Santa

Fe, and James Brown and Samuel H. Woodson were contracted to deliver mail to Salt Lake City. The first mail bound for the west left Independence in 1850.

Independence enjoyed great prosperity during the three trails decades. Much of the commercial activity in Independence supported the pioneers and immigrants as they outfitted themselves for their journey west. There were wagonmakers, blacksmith shops, gunsmiths, wheelwrights, saloons, livery stables, carpenters, grocers, tinsmiths, harness makers, mule and oxen sellers, dry goods merchants, flour mills, woolen mills, and hotels. Fur traders, trappers, Native Americans, Mexicans, and local farmers walked the streets. Independence was crowded, loud, and full of people fighting and drinking at all hours of the day and night.

The growth in Independence was such that the Missouri General Assembly granted a home rule charter in 1849, replacing the county court and trustee government. The city was defined as one mile square with the county courthouse in the center, increasing the area within the city limits from 240 to 640 acres.

Independence lost its monopoly on wagon-trail commerce to nearby Westport, and the town was no longer the last stop on the western frontier. The slavery feud and border war that began in 1854 and lasted past the end of the Civil War also impacted the city's fortunes. The bushwhackers, Missourians who favored slavery, waged a battle against the antislavery Kansas jayhawkers all along the western boundary of Jackson County. The most famous raiders were John Brown from Kansas and William Quantrill from Missouri.

The border war was a prelude to the horrors of the Civil War battles fought in Jackson County. Independence was a hotbed of secessionist sentiment when the city was made a federal post in 1862, the year of the first battle of Independence, won by Confederate soldiers in August. In 1863, several Jackson County women were crushed to death when the jail in which they were held collapsed in Kansas City. In retaliation, Quantrill and his band of raiders burned hundreds of homes and killed more than 180 men and boys in a vicious raid on Lawrence, Kansas. Four days after Quantrill's raid, Brig. Gen. Thomas Ewing issued Order No. 11, requiring all residents to leave their homes and property. Union soldiers won the second battle of Independence in October 1864.

After the Civil War, Independence residents began to rebuild their lives and economic security. During the 1880s and 1890s, many refined homes were built, schools were opened, and businesses grew. A boulevard connecting Independence with Kansas City encouraged population growth in the Englewood, Maywood, Fairmount, and Mount Washington areas. By 1900, Independence was again prosperous and offered a wonderful small-town life.

For the next several decades, as the nation went, so did Independence. Young men marched off to World War I, and returning veterans took significant leadership roles in the city and county. Harry S. Truman was elected judge of the county court, then United States senator, vice president, and president. Roger Sermon became mayor and served 26 years. New businesses and manufacturing companies were started and grew substantially, until the Great Depression. In 1926, the Soldiers and Sailors Memorial Building was completed and the RLDS auditorium was begun. A new Jackson County courthouse was completed on the town square in 1933.

Over time, Independence grew from a residential suburb of Kansas City and agricultural center to a business center with its own suburbs. In 1948, Independence had a population of 16,000 and about the same boundary lines as it had in 1889. Land annexed in 1948 increased the city's area from 3.4 to 10.3 square miles. Independence's population in 1950 was 36,963.

By 1975, additional annexations enlarged the city to more than 78 square miles, and the 1970 population had increased to 111,662. The city's sprawl contributed to the decline of the town square and older areas of town such as the Maywood, Englewood, and Noland Road districts. The city government and chamber of commerce have accepted the challenges raised by those concerns and have made the revitalization of the western portion of town and the town square a high priority.

Readers are invited to take a pictorial trip through Independence's history to see who came here first, what they did, and how they worked to make Independence the wonderful community that so many are very proud to call home.

One

QUEEN CITY
OF THE TRAILS

Independence was founded in 1827 on a heavily wooded 160-acre tract of land three miles south of the Missouri River. The land was attractive to settlers because it had 16 free-flowing springs of relatively pure water and provided much of what was needed to make it the marketing center for the surrounding agricultural area. Independence was also a good location because transportation from St. Louis could arrive in town without crossing the Missouri River.

As early as 1821, William Becknell had charted a trail between Independence and Santa Fe, Mexico. By 1831, the town was the outfitting headquarters for the pack mule and ox-drawn wagon trains that carried up to 7,000 pounds of merchandise to Santa Fe. During the 1830s and 1840s, carpenters, wagonmakers, livestock sellers, wheelwrights, blacksmiths, farmers, and all sorts of merchants relied on the Santa Fe business. The dependency was such that when Mexico imposed high tariffs on the goods brought from Independence, many Jackson County men volunteered for military service in the war with Mexico during 1846 and 1847.

Because of Independence's success in outfitting Santa Fe traders, the town became a base for westward migration. In 1848, most of the 12,000 people who went over the Oregon Trail to the Pacific Northwest started their travel in Independence, and many of the California gold rush prospectors of 1849 also left from the town. During the decades of the 1830s, 1840s, and 1850s, more than 250,000 people headed west, and most of them were outfitted in Independence. In 1850, the population of Independence and the surrounding township was 6,458, considerably larger than Kansas City and its township, which had 2,529 residents.

By the late 1850s, Independence had lost its virtual monopoly on wagon-trail commerce to nearby Westport and was no longer the last stop on the western frontier. The bloody border war over slavery between Missouri bushwhackers and Kansas jayhawkers began in 1854 and lasted to the Civil War. The Civil War had a profound impact on Independence, including two battles waged on the town square and the enforcement of the infamous Order No. 11 that required all area residents to leave their homes and property.

After the Civil War, Independence residents began to rebuild their lives. The community built many refined homes, opened new schools, and grew new businesses during the 1880s and 1890s. By 1900, Independence was again prosperous and provided a wonderful small-town life.

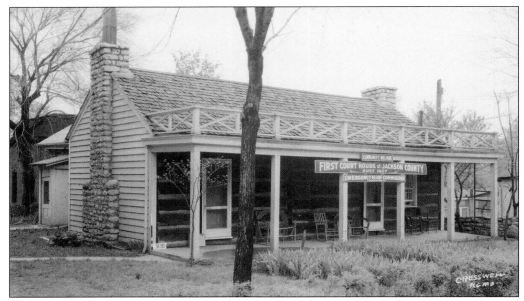

The first Jackson County courthouse was built by slave labor in 1827 with logs cut from the forest surrounding the site. Daniel Lewis, the low bidder, received $150 for constructing the two-room building. The county erected the first brick courthouse on the public square in 1830 and sold this building to Sidney Gilbert in 1832 for $371. In 1918, the original 1827 courthouse was moved to its current location on Kansas Avenue and restored as pictured here. (Library of Congress, Prints and Photographs Division.)

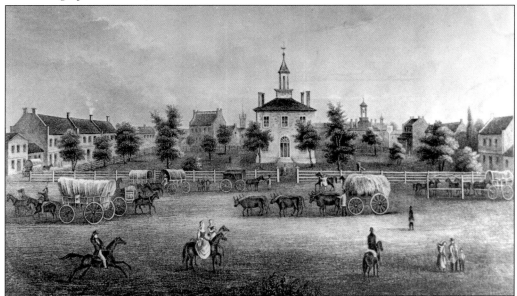

Herrmann J. Meyer depicted the Independence courthouse square in a steel-plate engraving for his illustrated travel series "Meyer's Universum," published in 1857. The county courthouse in the image was the second one built on the town square. The first brick courthouse was so badly built that it was razed in 1836, and this building replaced it, using only the foundation of the first building. (Harry S. Truman Library.)

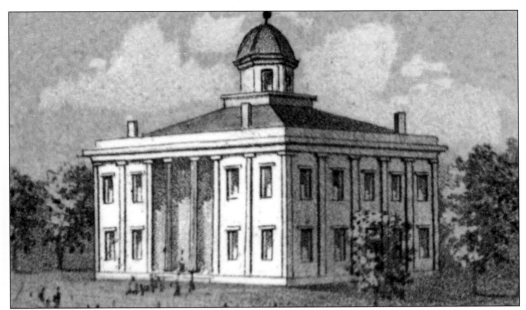

In 1848, this remodeled version of the county courthouse graced the town square. The building was enlarged, its exterior walls were refaced, more windows were added, and tall columns were extended from the ground to the roof all the way around the building. The spire had been cut down and replaced by a small cupola. The previous brick courthouse remained in the center of the remodeled building. (Library of Congress, Geography and Map Division.)

The Missouri General Assembly granted a home rule charter to Independence in March 1849, and voters approved the charter that June after the first attempt to pass it failed. The design of the common seal, adopted when the town was incorporated, depicts four Missouri mules pulling a covered wagon. Even though most of the westward-bound wagons had been pulled by oxen since 1829, mules appeared on the seal because the town was founded in 1827. (Richard N. Piland.)

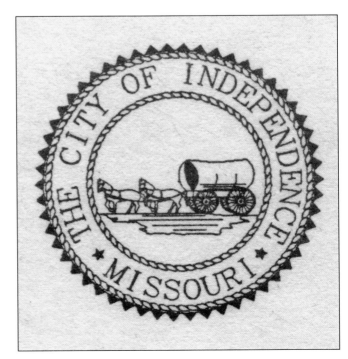

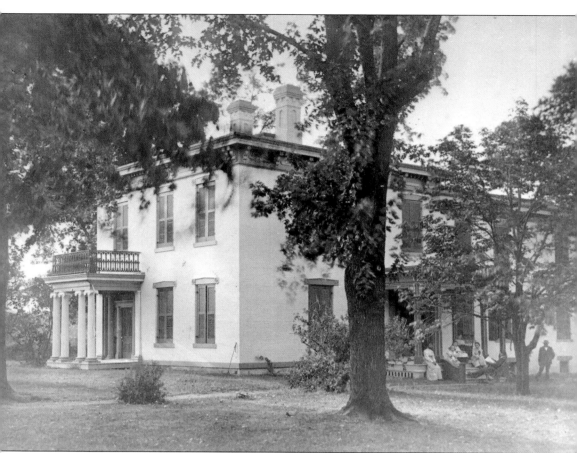

William McCoy was elected the first mayor of Independence in 1849. He had come to Missouri in 1838 and became involved in the trading business. He and partners David Waldo and Jacob Hale secured the first contract to carry mail from Independence to Santa Fe, Mexico. During the Civil War, he and several other businessmen organized the First National Bank, and after that bank closed, they operated the McCoy Banking Company. McCoy also served on the first Independence School Board in 1866. The McCoy home, located on the corner of Spring Street and Farmer Street, was built sometime before 1850. The property included 14 acres of land, several outbuildings, and slave quarters. In this picture, five members of the McCoy family are sitting on the porch on the east front side of the house. The two people at the far left and right might be Amanda and Ben Tucker, former slaves who worked for the McCoy household long after slavery ended. (Harry S. Truman Library.)

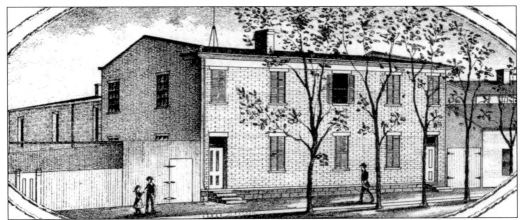

The town's first jail, built in 1827, burned down and was replaced by a larger brick jail in 1841. That jail was replaced in 1859 by the jail seen in this image from an 1877 county atlas. Frank James, the notorious outlaw and member of William Quantrill's band, was held in this jail for almost six months while he awaited trial for train robbery and murder. Independence residents treated him as a hero and celebrity, and the jury at his 1863 Gallatin trial acquitted him of all charges. (Jackson County Historical Society.)

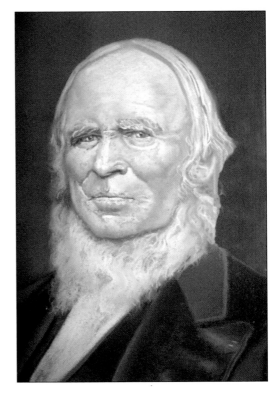

John Wilson arrived in Independence in 1836 and became a merchant, selling goods to travelers heading west over the three trails. As one of the first to establish residency in the town, he was considered one of the original old settlers. He was a trustee of the Southern Bank of St. Louis, which did business in Independence from 1858 to 1878. Wilson was 54 years old when this 1859 portrait was painted. (Marietta Wilson Boenker.)

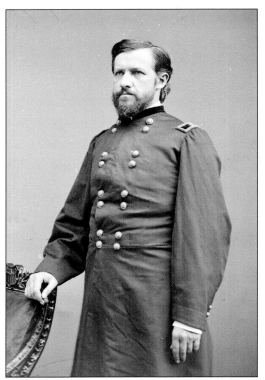

Thomas A. Ewing was the Union general who issued the infamous Order No. 11 on August 25, 1863. The order required all people living in Jackson, Cass, Bates, and Vernon Counties to leave their homes within 15 days. Many Independence residents were banished, and their homes, property, and crops were burned. Ewing issued the order four days after William Quantrill and his band of bushwhackers staged their bloody raid on Lawrence, Kansas. (Library of Congress, Prints and Photographs Division.)

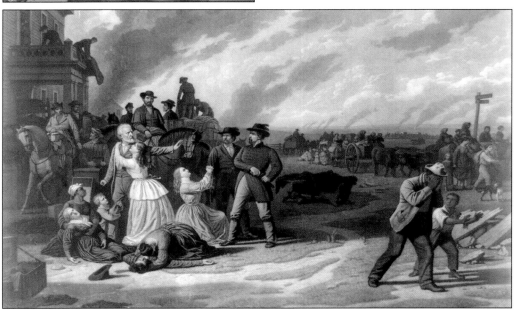

George Caleb Bingham strongly resented Order No. 11 and traveled from Jefferson City, where he was serving as state treasurer, to personally appeal to Ewing to rescind the order. The order stood, and Bingham protested its implementation by painting *Martial Law, or The War of Desolation*, better known as *Order Number 11*. The image seen here is based on the 1870 engraving of the painting made by John Sartain. (Harry S. Truman Library.)

This home was the residence of Bingham and his family from shortly before the outbreak of the Civil War to 1870. Bingham maintained a studio in the log-and-clapboard building on the right side of the picture. *Order number 11* was painted in this studio. In 1879, the property was purchased by Peter and William Waggoner of the Waggoner-Gates Milling Company. The studio was torn down in 1901. (Harry S. Truman Library.)

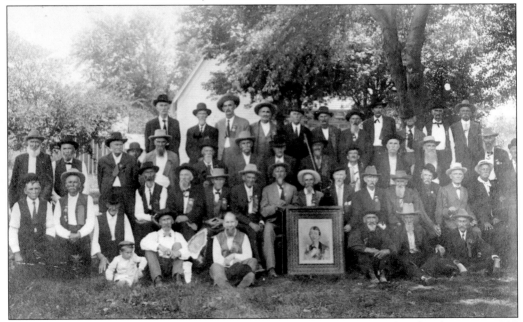

Reunions of surviving members of the William Quantrill band of rough riders began in 1888 and were held annually in either Independence or Blue Springs. The people in this picture were attendees of the ninth reunion of the band. The last reunion of survivors was held in 1929. (Harry S. Truman Library.)

Robert Weston built his blacksmith shop in 1847 on the southwest corner of Liberty and Kansas Streets, where he repaired guns and saddles and shod horses. He also built prairie schooner wagons and manufactured steel-tipped plows in large wooden sheds on his property. This picture was taken on April 24, 1926, during the dedication of a granite monument honoring Weston by the Independence Chapter of the Daughters of the American Revolution. The shop was razed in 1931. (Harry S. Truman Library.)

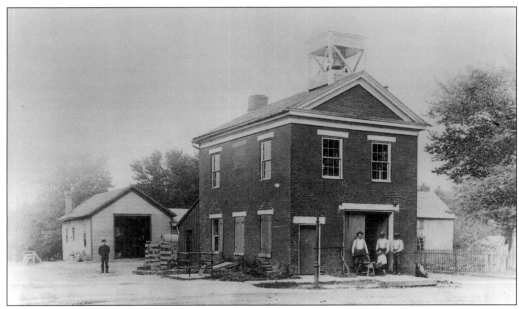

This building was known as the engine house when it was built in 1858. It was located on Osage Street between Lexington and Maple Streets and housed the Independence Fire Company's hose cart and man-powered pumping engine, the *Independence 76*. The second floor of the building held offices for the mayor and the street commissioner and the city council chambers. The building was razed in 1906. (Independence 76 Fire Company Historical Society.)

On June 13, 1866, a gang of horse thieves confronted Sheriff Henry Bugler at the 1859 jail on Main Street. They demanded the release of two members of their band being held there. Bugler refused. The thieves killed the jailor, wounded his four-year-old son, and released the prisoners. Bugler was buried in Woodlawn Cemetery. This picture shows the inscription on his gravestone. (Independence Police Department.)

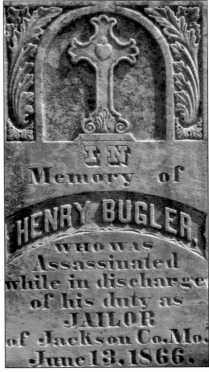

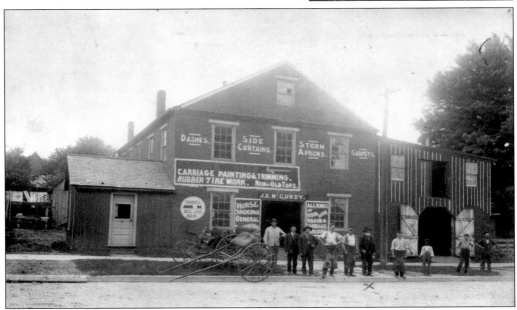

John G. McCurdy established his business in 1852 when he bought this blacksmith shop located at the corner of Main and White Oak Streets. He specialized in making plows and farm implements and repaired buggies and mail coaches. Al McCurdy, a son, sold the shop in 1915, and several subsequent owners continued blacksmith operations until the building was razed in 1973. (Harry S. Truman Library.)

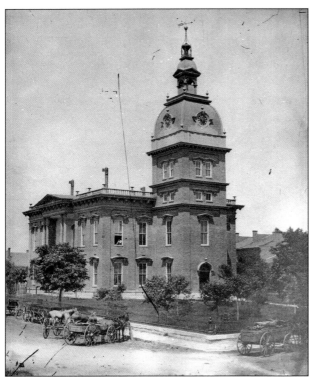

The county courthouse on the town square was remodeled again in 1872. The entire structure was refaced with red brick, and a wing with a pointed tower and clock was added on the east side of the old structure. A railing with ornamental Grecian urns ran along the top of the building. The tall columns of the 1848 courthouse were removed, and porches were built over the north and south entrances. (Harry S. Truman Library.)

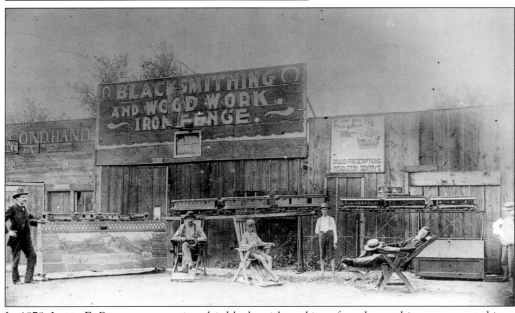

In 1878, Justin E. Page was operating this blacksmith and iron foundry, making ornamental iron fences, jail-cell bars, bank teller cages, and electric light poles. Page invented and patented a railroad passenger coach that he claimed would be safe in train collisions. The miniature model train cars in the picture were part of the Page Safety Car Company's strategy to advertise his innovation. (Harry S. Truman Library.)

Independence's first theater was the Wilson Opera House, built in 1874 by Samuel, Charles, and Rufus Wilson. The three Wilson brothers located their business on Main Street opposite the county courthouse. The first floor of the building was a grocery store, while the theater occupied the second floor. The opera house could seat 600 people and serve as a ballroom. In 1886, Charles sold the building to interests that started the A. J. Bundschu Dry Goods Store. (Jackson County Historical Society.)

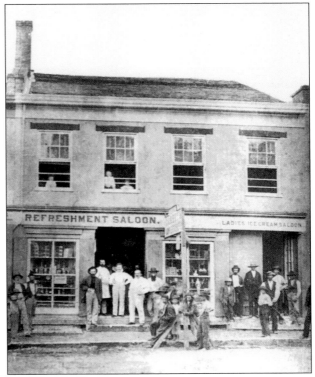

Mathias Peiser bought a half interest in the Uhlinger Bakery located on Lexington Street on the south side of the town square in 1865. Five years later, he added a saloon and became sole owner. This 1873 photograph shows two separate entrances to the establishment and several customers. The post apparatus outside the saloon is thought to be a device to help intoxicated customers stay on their feet. The Peiser family operated this business for two generations. (Bill Curtis.)

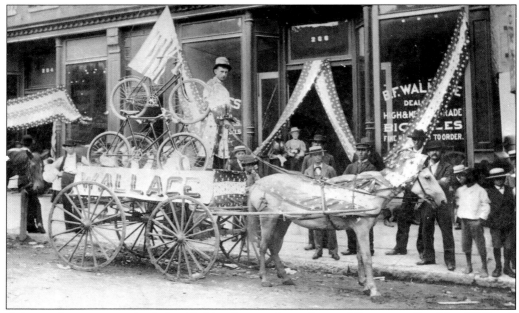

A horse-drawn wagon loaded with bicycles stands in front of Benjamin Franklin Wallace's bicycle store in this photograph from about 1875. Wallace was Elizabeth Virginia (Bess) Truman's grandfather. He served as mayor of Independence in 1869 and at the time of his death in 1877 was a member of the Missouri legislature representing Jackson County. (Harry S. Truman Library.)

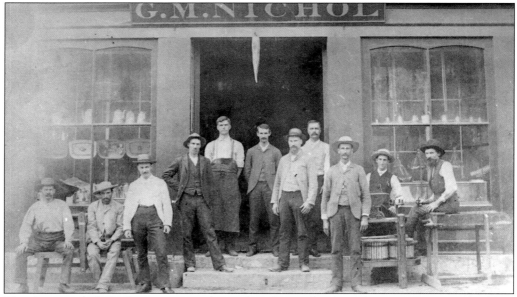

The G. M. Nichol Hardware store was located on the south side of the town square in a building that was destroyed by fire in 1906. The store reopened the day after the fire in a new location on Main Street and subsequently changed its name to Independence Hardware Company. The men outside the store in this 1886 picture, from left to right, are Martin Casper, John Bates, Chauncey Carroll, Charley LaVell, Charley Hill, Wallace Gregg, Nichol, John Hill, John White, Walter Gregg, and ? Bruner. (Harry S. Truman Library.)

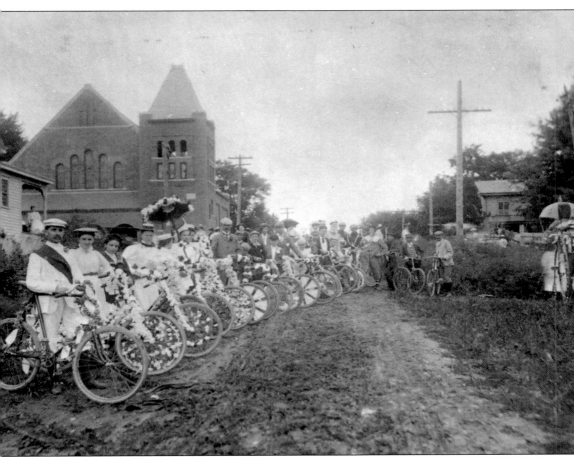

Recreational activities were relatively simple for most residents of Independence by the end of the 19th century. In this 1890 picture, participants in a bicycle parade pause for a group portrait. The location where the photograph was taken or the reason for the parade is not known. (Harry S. Truman Library.)

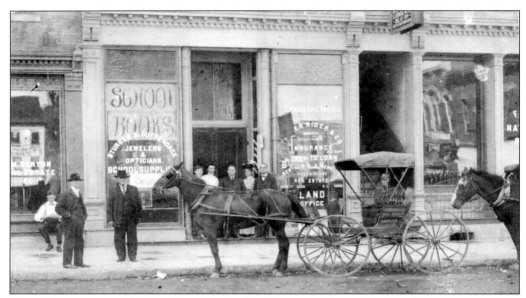

Harry Sturges opened his jewelry and schoolbook store on the north side of the town square in 1898. The next year, he relocated to the west side of the square and remained at that address for more than 50 years. Sturges gave medals to high school seniors for excellence in art, essay writing, and other academic areas. The first medals were awarded in 1900 and then annually for the next 53 years. (Harry S. Truman Library.)

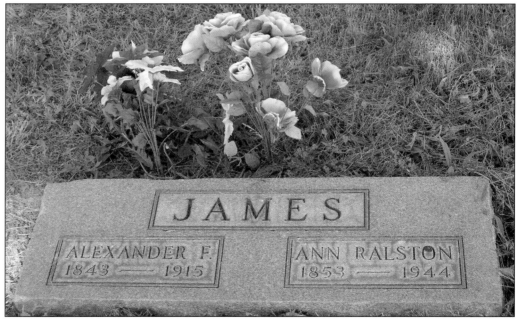

Alexander Franklin (Frank) James, his brother Jesse, and their gang flourished for 15 years from 1866 to 1881. During those years, they held up 12 banks, seven trains, and five stages in 11 states and territories. Frank died in 1915 at the age of 73. In 1944, his wife, Ann Ralston James, died, and their ashes were buried in a family cemetery near Maywood Avenue and Twentieth Street on the northern edge of Hill Park. (Richard N. Piland.)

Two

SERVING THE COMMUNITY

Among the first community-oriented structures built in Independence were the original log courthouse and jail in 1827. The decisions about those buildings, the platting of the town, and the first sale of lots for settlement were made under the auspices of the Jackson County Court. In fact, the county court was the town's government until Independence was granted a home rule charter in 1849. From that date, the city's business was determined by an elected mayor and city council.

In 1843, the first organized fire protection in Independence was a volunteer fire company that was ill equipped to deal with fires since it only had buckets, axes, and hooks. In 1853, the city acquired its first fire engine and a hose cart that enabled volunteers to hand pump water from cisterns or wells to put out fires. By 1858, the engine house was built to house the fire engine, its horses, and offices for city officials. During the 1880s, four water cisterns, one on each side of the town square, and their hydrants allowed better protection, but there were still many destructive fires throughout Independence. The first modern, motorized fire engine was acquired by the city in 1928.

For many years, law enforcement in town was administered by the county sheriff. In 1878, the city council created the night watch to patrol the town. Four years later, the Independence Police Department was created by city ordinance and the five-man force replaced the night patrol. Each officer received $1.30 for working a 12-hour shift. City policemen dressed in civilian attire except for a badge and billy club until uniforms were provided starting in 1909. The department purchased its first vehicle in 1919.

Other municipal services were developed to meet the needs of the community's residents. Water was seldom a problem since Independence was built on land with 16 natural springs. The city's waterworks was constructed in 1884, and the town has continued to provide pure water. The first municipal power and light plant was built on Dodgion Street in 1901, and the utility has been kept up to date to meet community needs. Other organizations, such as local clubs, societies, service groups, church groups, and businesses, also work to serve the community.

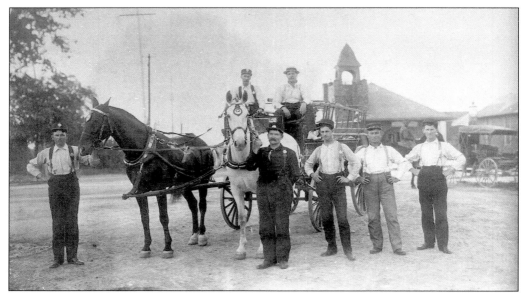

The Independence Fire Department's first team of horses and their hose wagon stand near the Air Line Railroad depot in 1901. The firemen, from left to right, are (standing) D. A. Kinkade, Chief John Nesbitt, William Goodman, Charles Highfel, and ? Nesbitt; (seated) Lewis Warren and Ellis Wright of the *Jackson Examiner*. John Nesbitt was the city's first paid fire chief from 1896 to 1902 and in 1908. The department did not use horses after 1918. (Independence 76 Fire Company Historical Society.)

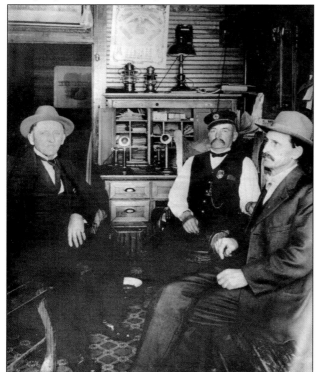

Fire Chief Charles E. Staub sits at his desk in the department's headquarters in this picture taken around 1910. The two councilmen meeting with Staub are Elijah Hutchison (left) and Joseph T. Noland (right). The department's headquarters was located near the corner of Main and Lynn Streets. (Harry S. Truman Library.)

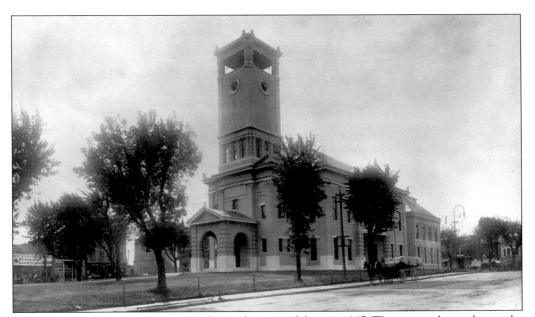

The 1872 county courthouse received a modest remodeling in 1887. This image shows the results of another remodeling effort completed in 1907. The pointed tower on the east side was cut down and squared off, the courtroom was enlarged, and the entire building was refaced. In 1910, the municipal light company installed four incandescent lamps to light the face of the clock. (Harry S. Truman Library.)

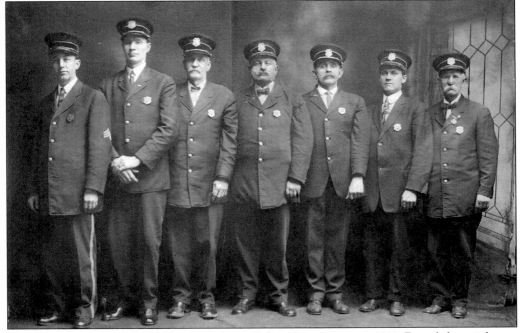

These seven men made up the Independence Police Department in 1914. From left to right are James Stewart, Chief Nealy Harris, Patrick Costello, William Tate, ? Russell, ? Noland, and John A. Workman. (Independence Police Department.)

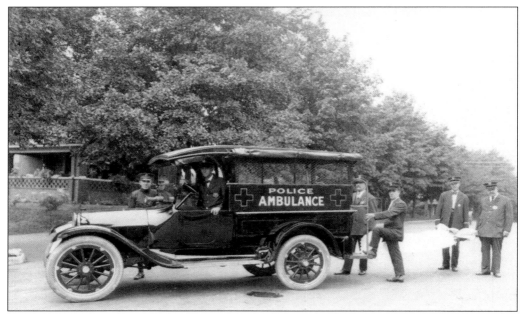

In 1919, the Independence Police Department was given the funds it needed to purchase its first vehicle. The department bought the ambulance seen in this photograph. During the previous year, city funds enabled the fire department to acquire its first two motorized fire engines. (Independence Police Department.)

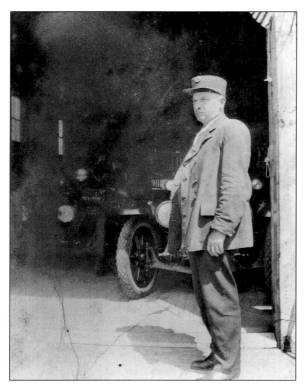

Fire Chief David A. Kinkade stands outside the doorway of firehouse No. 1, located on the corner of Osage and Lexington Streets, in this 1921 photograph. Kinkade joined the Independence Fire Department in 1900 and was its chief from 1902 to 1908 and from 1913 to 1950. The wooden frame building served as firehouse No. 1 from the early 1900s to 1928. (Independence 76 Fire Company Historical Society.)

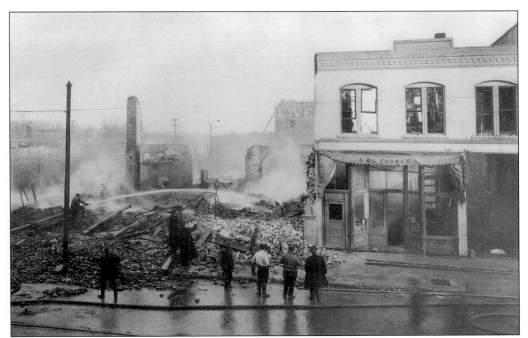

A disastrous fire destroyed the 1895 McCoy Music Hall, 15 other businesses in the 200 block of West Maple Avenue, and the Ott building on North Liberty Street in February 1915. The loss was estimated at $100,000. This picture shows the rubble from the music hall building. (Independence 76 Fire Company Historical Society.)

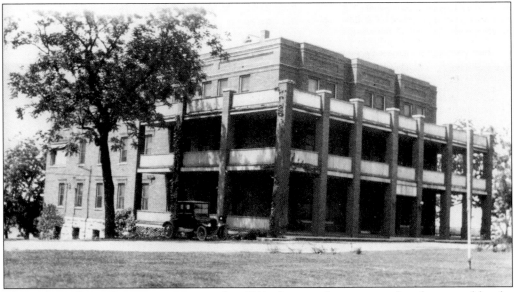

The Independence Sanitarium, seen in this 1911 photograph, was owned and operated by the Reorganized Church of Jesus Christ of Latter Day Saints (RLDS). The building opened in 1909 with 40 rooms and a hospital ward. A school of nursing was established at the facility in 1910 and trained nurses until 1935, when the program was taken over by Graceland College. The sanitarium was razed in 1985. (Richard N. Piland.)

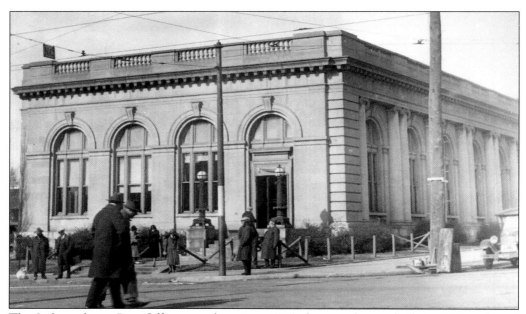

The Independence Post Office, seen here in a 1925 photograph, was built in 1911 and used until 1965. It was located on Osage Street between Maple Avenue and Lexington Street. The total cost of the cut-stone Grecian-style structure was $100,000 for the grounds, building, and equipment, not including an addition made in 1932. William Bostian was postmaster when the post office opened. (Harry S. Truman Library.)

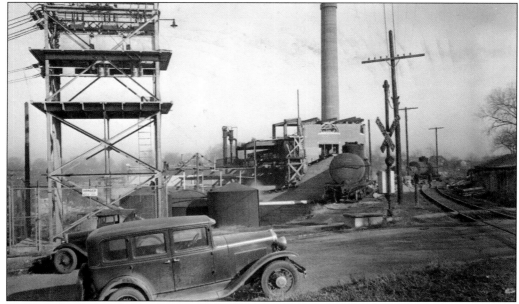

Independence's first municipal power plant began generating electricity at its facility located on Dodgion Street between Maple Avenue and Lexington Street in 1902. The city replaced that plant with a new one built on the same site between 1926 and 1932 at a cost of $300,000. This picture dates from 1926 or 1927 when construction of the new plant was just getting started. (Roger T. Sermon Community Center.)

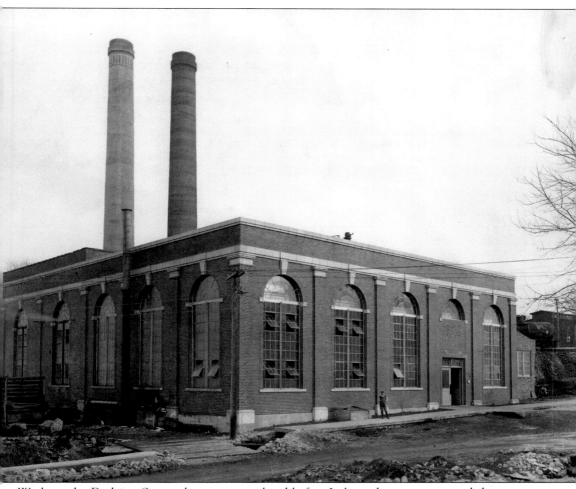

Work on the Dodgion Street plant was completed before Independence experienced the onset of the Great Depression. The city's new power plant, seen here in a 1936 photograph, was able to meet the community's electric needs for several years. (Roger T. Sermon Community Center.)

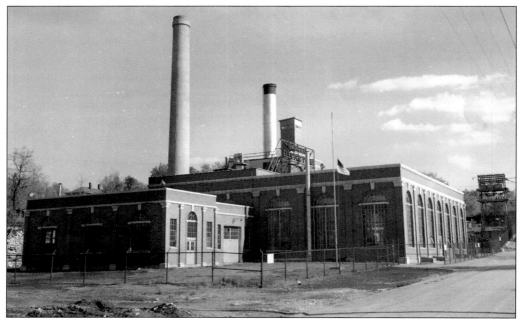

When Independence began a series of eight annexations in 1948, increased demand for electricity caused the city to expand the Dodgion Street plant by building additions and adding more power-generation capacity during the early 1950s. This photograph shows the plant as it looked after those improvements. (Roger T. Sermon Community Center.)

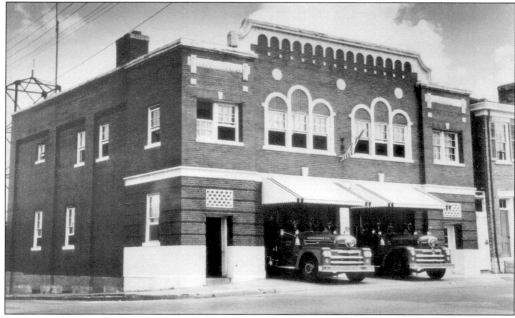

This new brick firehouse No. 1 on North Main Street replaced an old, wooden fire station on the same site in 1928. The Independence Fire Department's headquarters was in this building until 1972, when a newer station was built. The two fire trucks in the doorway are a 1960 Seagrave pumper and a 1952 Seagrave aerial truck. (Independence 76 Fire Company Historical Society.)

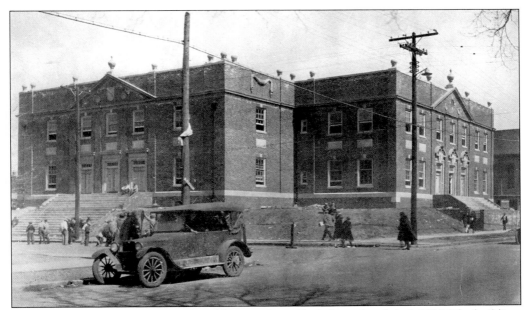

The Soldiers and Sailors Memorial Building was formally dedicated on July 4, 1926. The building, located on the northeast corner of Pleasant Street and Maple Avenue, was built as a memorial to those who lost their lives in World War I. It was made possible by the sale of $150,000 in bonds during a community-wide campaign. In 2002, the building was renovated and rededicated for the community's use. (Richard N. Piland.)

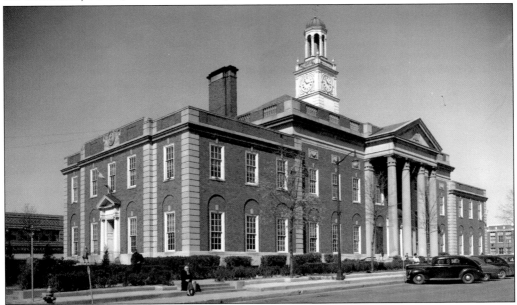

The last remodeling of the Jackson County Courthouse, completed in 1933, was planned under the direction of presiding judge Harry S. Truman and county judges E. I. Purcell, Battle McCardle, and W. O. Beeman. The new structure was inspired by Independence Hall in Philadelphia and cost $200,000. The center of the building and the clock tower are supported by portions of the six earlier courthouse structures and additions dating back to 1828. (Harry S. Truman Library.)

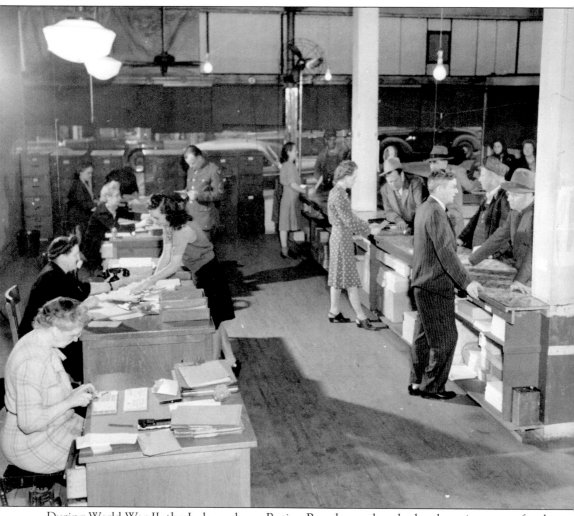

During World War II, the Independence Ration Board served as the local service center for the residents of Jackson County, except those who lived in Kansas City. It was in this office that local citizens dealt with issues related to the rationing of gasoline, coffee, sugar, and cheese. (Harry S. Truman Library.)

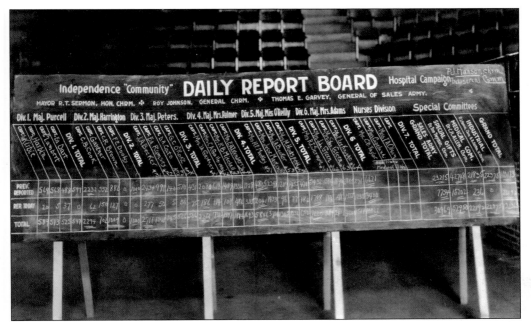

A fund-raising campaign to build a new hospital was begun in 1930 by the RLDS and the community. The project was delayed by the Depression, but the federal government awarded a $288,000 grant in 1941. The daily report board seen in this photograph displays the number of dollars raised by members of the Independence community for the new hospital. (Independence Chamber of Commerce.)

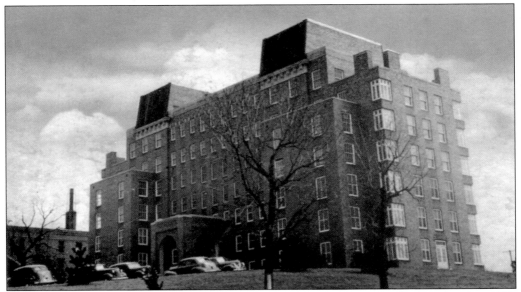

Construction of the new Independence Sanitarium and Hospital was finally completed in 1952. The building that had taken more than 20 years to complete was built next to the old sanitarium on Truman Road. The hospital had 200 beds and could treat more than 8,000 patients each year. The nursing school at the facility could accommodate 100 students a year in the hospital's three-year program. (Marietta Wilson Boenker.)

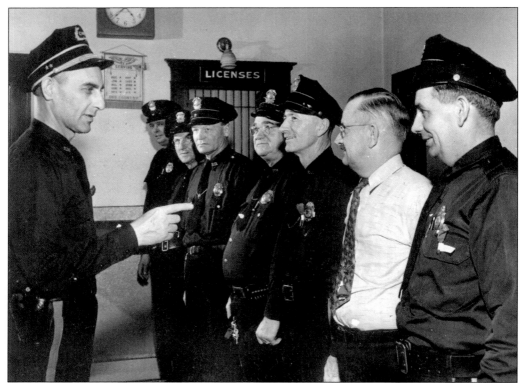

Police chief Hal Phillips speaks to his officers in the department's headquarters in the city hall building in this 1945 photograph. In that year, the Independence Police Department had a staff of 13 policemen and three radio cars. Phillips served as chief for five years, from 1945 to 1950. (Harry S. Truman Library.)

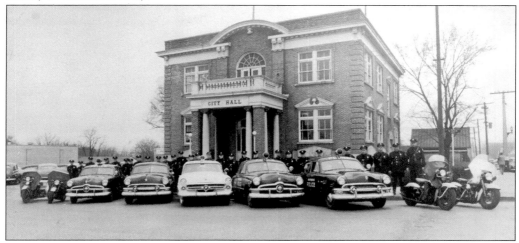

Members of the Independence Police Department stand behind their squad cars in front of the city hall building in this photograph taken in the early 1950s. The building, located on the corner of South Main and Kansas Streets, was completed in 1911 at a cost of $30,000. It served as police headquarters for 64 years. The facility included a large city council chamber, a jail, and an underground gun range. (Independence Police Department.)

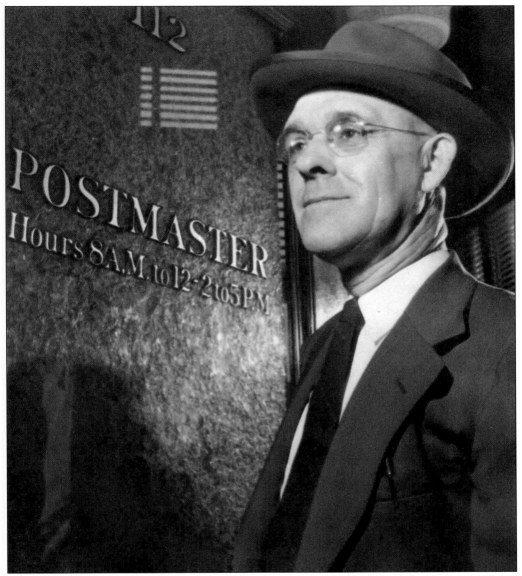

Postmaster Edgar G. Hinde stands in the Independence Post Office in this 1945 photograph. Hinde had served in World War I with Harry S. Truman and Roger T. Sermon. He was the first park superintendent for Jackson County from 1927 to 1935 before he became postmaster. He served as postmaster for 25 years, from 1935 to his retirement in 1960. (Harry S. Truman Library.)

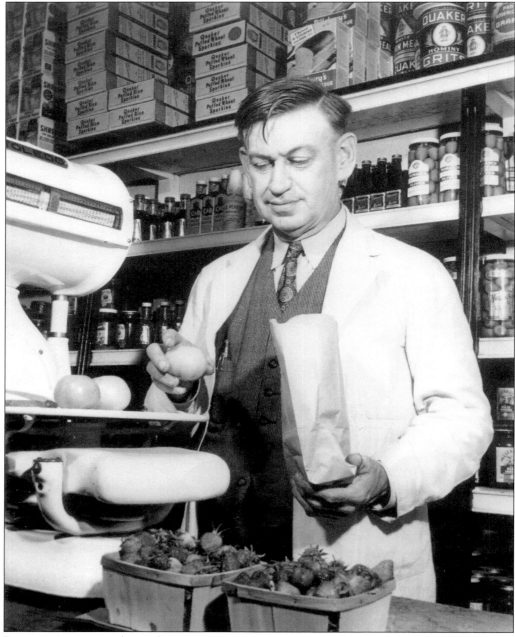

Roger T. Sermon works in the grocery store on West Maple Avenue that he and his partner, Powell Cook, owned. Sermon had served with Harry S. Truman during World War I. He served as a city councilman for two years before being elected mayor in 1924. He was the mayor of Independence from 1924 to 1950, longer than any other person. (Harry S. Truman Library.)

Five unidentified members of the Independence Fire Department stabilize a Bangor ladder and its tormenter poles as two firemen climb to a height of about 50 feet above the ground. The ladder is being tested against the grain elevator at the Waggoner-Gates Mill in this photograph taken in 1950. Bangor ladders were often used when a burning structure was inaccessible by a fire department's ladder truck. (Independence 76 Fire Company Historical Society.)

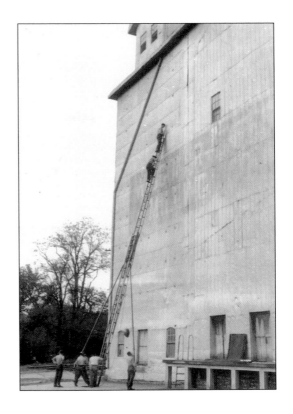

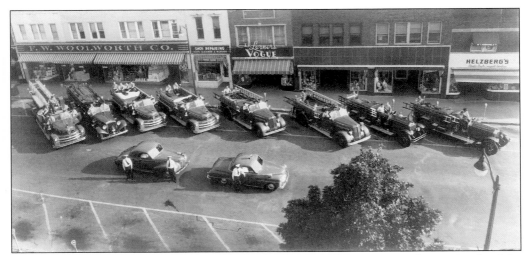

The men and equipment of the Independence Fire Department are seen on the north side of the town square in this picture taken from the Jackson County Courthouse in 1952. From left to right, the department's eight fire trucks parked along Maple Avenue are a 1952 Seagrave aerial truck, a 1936 American LaFrance quad truck, two 1952 Seagrave pumpers, two 1949 pumpers, and a pair of 1928 American LaFrance pumpers. The vehicles in the front row are the fire inspector's 1940 Buick (left) and the fire chief's 1950 Dodge. (Independence 76 Fire Company Historical Society.)

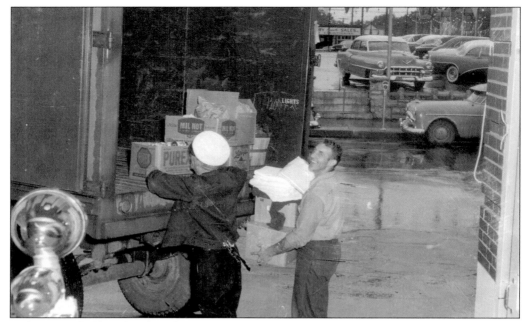

Mel Spitser (left) and Bob Lyday, two members of the Independence Fire Department, load a truck with clothing and canned food that was donated for victims of a May 1957 tornado. The tornado completely destroyed much of the Ruskin Heights area of Jackson County, including Ruskin High School. (Independence 76 Fire Company Historical Society.)

Thomas J. Pollard joined the Independence Fire Department as a hoseman in 1923. He became fire chief in 1950 when the department had 12 firemen at two fire stations protecting a population of about 16,000 people. Before Pollard stepped down as chief in 1968, the fire department had more than 100 firemen and eight stations protecting nearly 100,000 residents. (Independence 76 Fire Company Historical Society.)

An Independence firefighter works to extinguish the Watt Webb castle fire in December 1977. The stone castle on Truman Road was a replica of an old European castle and was a local landmark since around 1900. The castle was neglected and greatly deteriorated before a fire destroyed the carriage house on the property in 1976. (Independence 76 Fire Company Historical Society.)

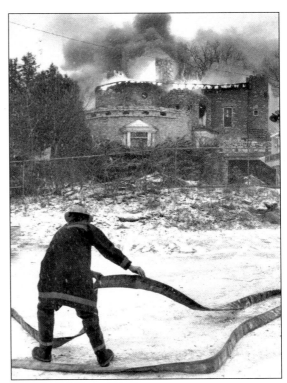

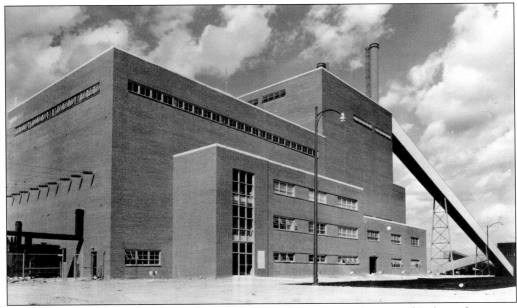

Construction of the city-owned Blue Valley Power Station six miles east of Independence was completed in July 1958. The old Dodgion Street power plant, even with the frequent upgrades made there, had difficulty keeping up with the demand for electricity that resulted from city annexations. This new 44,000-kilowatt station, with several subsequent upgrades, provided the city with energy independence for the next 40 years. (Independence Chamber of Commerce.)

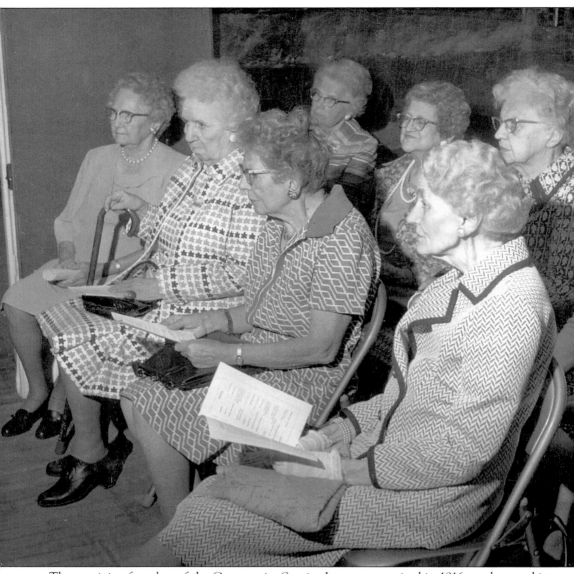

The surviving founders of the Community Service League, organized in 1916, are honored in a 1972 ceremony. From left to right are (first row) Martha Reed, Eleanor Minor, Grace Minor, and Marguerite Kerr Hudnall; (second row) May Southern Wallace, Helena Fuchs Crow, and Lucille Hatten Kerr. (Community Service League.)

Three

THE TOWN SQUARE

The public square is a traditional town feature of most American communities, especially western cities. When Independence was platted in 1827, the town square was designed to have a courthouse as the anchor of the community. During the first public sale of lots, the ones fronting streets surrounding the courthouse typically cost more than did lots farther from the planned town center.

The Jackson County Courthouse has stood at the center of town since the first permanent courthouse was erected in 1830. That first building was torn down and replaced by a better constructed one in 1836. Over the years, the courthouse building was remodeled four additional times in 1848, 1872, 1887, and 1907 before the current facility was opened in 1933.

The four streets around the square were all macadamized with crushed rock that had been quarried on the east side of town. On the north side of the square was Rock Street, which was most likely named because it led to the rock quarry east of town. Main Street on the east was likely named because it was to be a popular business and residential street. Lexington Street on the south was the road leading to Lexington, the county seat of Lafayette County. And on the west side was Liberty Street, which had been named in honor of Liberty, the county seat of Clay County.

During the very early years, residences and businesses surrounded the town square, but by the time Independence was outfitting Santa Fe, Mexico, traders and pioneers traveling west, the town was all business. By 1885, the town square was occupied by two hotels, two banks, nine groceries and meat markets, six saloons, three drugstores, two barbershops, two furniture stores, five dry goods stores, three hardware stores, and the Wilson Opera House. Other merchants included harness makers, booksellers, feed stores, jewelers, millinery stores, boot and shoe stores, and a telegraph express office. Offices for lawyers, real estate agents, insurance agents, doctors, dentists, and fraternal clubs were located on the second and third floors of many buildings.

Over the years, the nature of the uptown area changed, adapted, and evolved as if the town square had a life of its own. Family merchants sold their businesses. Stores failed. Fires caused some businesses to move location. Economic conditions and population changes altered the landscape. The Independence town square was vibrant, exciting, and the heart of the community.

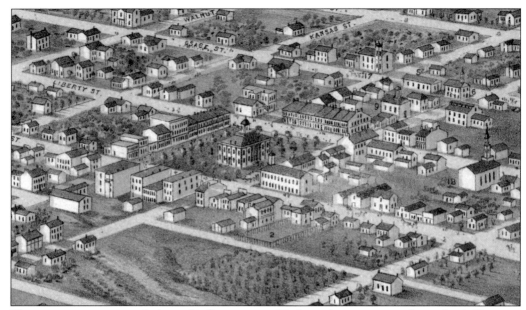

This image is a portion of a larger bird's-eye view of Independence as it was drawn by A. Ruger in 1868 and shows the 1848 county courthouse and town square. The view is from the northeast side of the square. The numbered structures in the map are the market house (5), engine house (6), Baptist church (9), Cumberland Presbyterian Church (17), Old School Presbyterian Church (18), and the 1859 Butler County jail (2). (Library of Congress, Geography and Maps Division.)

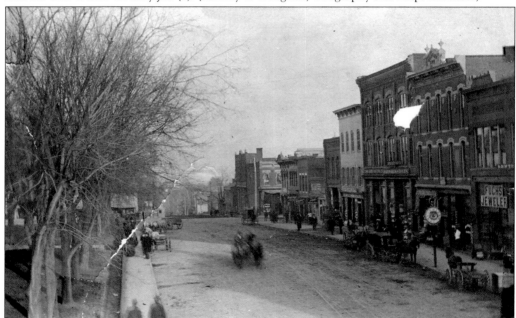

This 1899 photograph shows Lexington Street directly opposite the courthouse looking east from Liberty Street toward Main Street. The businesses located on this side of the square included Fuchs Jewelry, Peiser's Sample Room and Café, two other saloons, a dry goods and clothing store, a barbershop, a hardware store, a grocery store, and a confectionery. (Harry S. Truman Library.)

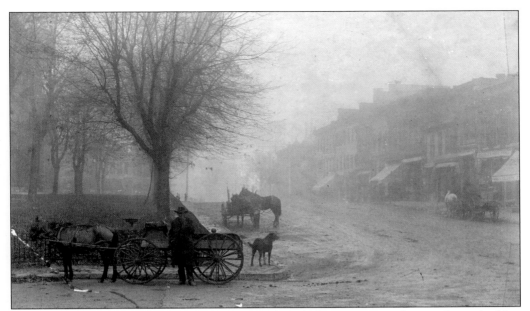

Another 1899 photograph provides a foggy view of Maple Street opposite the courthouse looking west from Main Street. The horse-drawn cart at the far right stands in front of the saddle shop owned by Charles P. Modie, son of one of the city's pioneer harness dealers. Modie sold his business to Henry Rummel, who, in 1924, became the only person to ever defeat Harry S. Truman in an election for a political office. (Harry S. Truman Library.)

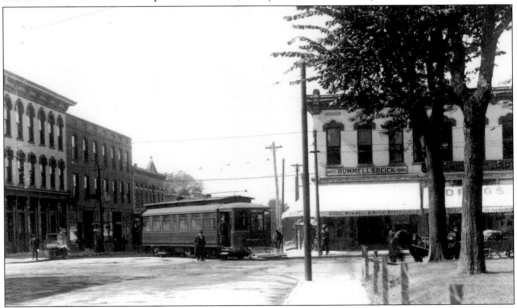

Metropolitan Street Railway car 243 turns off Lexington Street onto Liberty Street in this view of the southwest corner of the square in 1903. These dark green electric-powered cars replaced the steam-powered dummy line train that pulled cars to and from Independence and Kansas City in 1896. The principal owner of the Metropolitan Street Railway was Chicago meatpacker J. Ogden Armour. (Bill Curtis.)

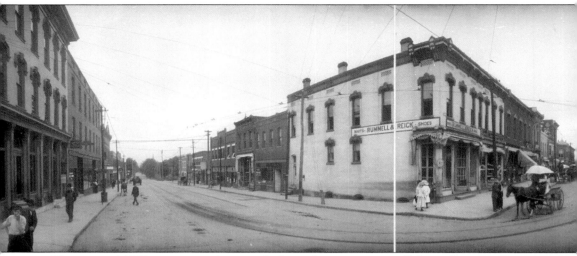

This unusual 1909 panoramic photograph shows the intersection of Liberty Street and Lexington Street. The left section shows Lexington Street as it runs west from the town square while the right section shows Lexington as it continues east forming the south side of the square. The center portion shows Liberty Street as it runs north along the west side of the square. The Chrisman-Sawyer Bank building is on the extreme left of the photograph. Stores on Liberty

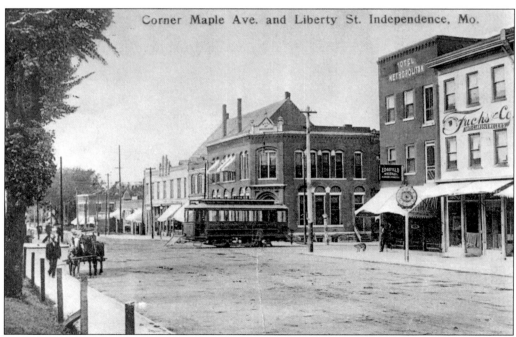

The Bank of Independence, Metropolitan Hotel, and Fuchs Jewelry store on the northwest corner of the square are seen in this 1913 postcard. C. W. Fuchs moved his jewelry store from its Lexington Street location to Maple Street in 1907. The Jones Hotel that operated on this corner since the 1830s was sold in 1906 and renamed the Metropolitan Hotel. The Bank of Independence was built in 1886. The electric trolley, a Birney Safety Car commonly called the "Goat," served neighborhoods to the north and south of town. (Harry S. Truman Library.)

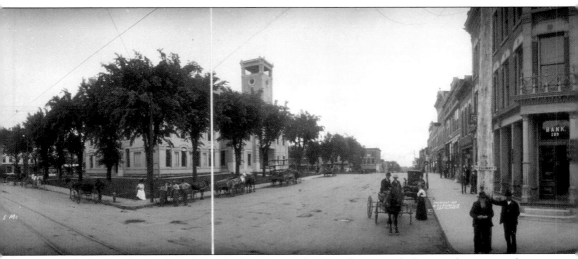

Street include the Rummel and Reick shoe store, the Pendleton and Gentry drugstore, the Bank of Independence, and the Metropolitan Hotel. The 1907 Jackson County Courthouse anchors the square. The building at the extreme right is the First National Bank, which is directly across Liberty Street from the Chrisman-Sawyer Bank. (Library of Congress, Prints and Photographs Division.)

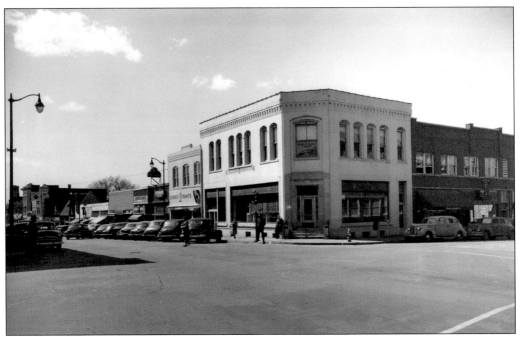

This 1950 photograph shows that the Bank of Independence building did not change much beyond a modest remodeling after the 1913 postcard was created. Maple Street west of Liberty Street, however, was quite different after a 1915 fire destroyed the music hall and many other businesses on the street. Some of the stores along this block were Cook's Paint and Varnish, Buehler Brothers Grocery, Army and Navy Supply Store, and Western Auto. (Harry S. Truman Library.)

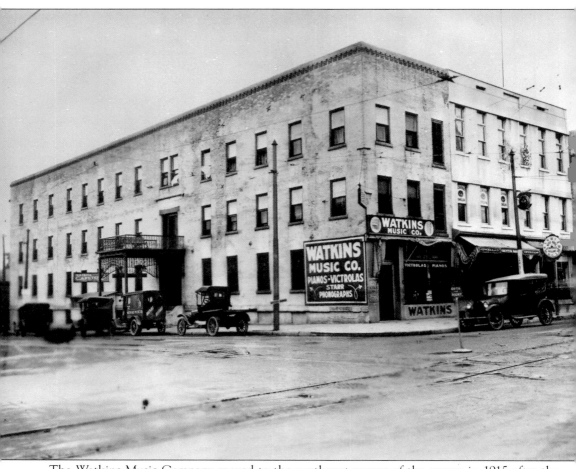

The Watkins Music Company moved to the northwest corner of the square in 1915 after the original store was destroyed in the music hall fire. In 1919, Watkins purchased the Metropolitan Hotel and reopened it as the Watkins Hotel. C. W. Fuchs moved his jewelry store to his upstairs rooms in 1919 and rented the lower store in the picture to the Betts brothers, who were licensed optometrists. (Harry S. Truman Library.)

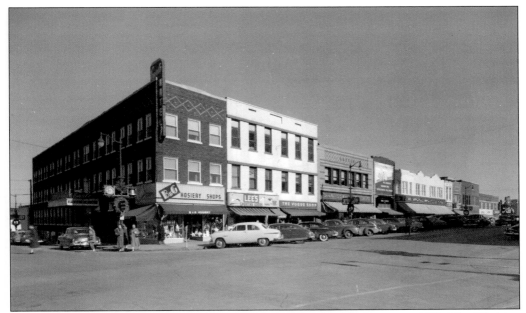

This photograph shows all the businesses on the north side of the square in 1951. The Watkins Hotel became the Earle Hotel in 1950 when the Detroit-based Milner Hotels leased the property. From left to right, the other stores in the western half of the block were B&G Hosiery, Lee's Sporting Goods, the Vogue Shop, S. S. Kresge's 5 and 10, Isis Shoes, and Woolworth's Five and Dime. (Harry S. Truman Library.)

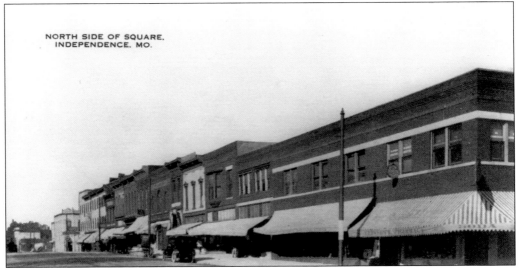

James H. Clinton's Pharmacy is at the extreme right side of this photograph taken after 1901. Some of the other stores located along this side of the square included a jewelry store, a dry goods store, a harness shop, a bookstore, two grocery stores, a saloon, and a hotel. Fourteen-year-old Harry S. Truman held his first job in 1898 working in Clinton's drugstore, where he cleaned, mopped floors, and worked at the soda fountain for $3 a week. (Harry S. Truman Library.)

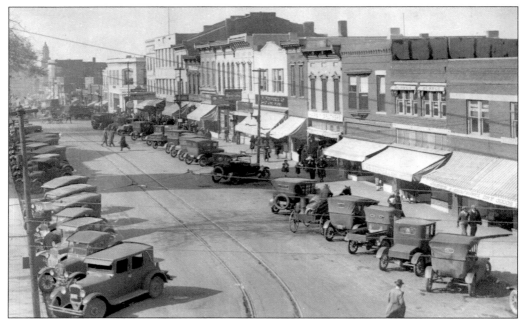

The town square was a bustling commercial center when this picture of the businesses along Maple Street was taken in 1925. Casper and Shimfessel's dry goods store, Knoepker's, Harbin Brothers men's clothing store, Mills' bookstore, Woolworth's Five and Dime, Watkins Music Store, and Watkins Hotel were popular businesses of the day. (Harry S. Truman Library.)

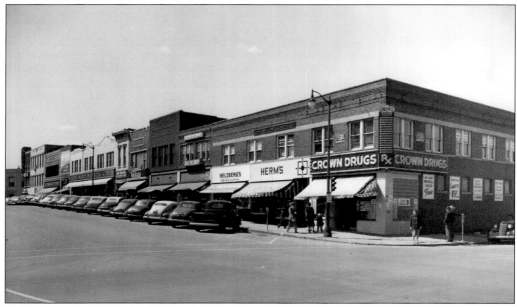

Independence remained a thriving business center throughout the 1930s, 1940s, and 1950s. This 1950 photograph shows the businesses along Maple Street as viewed from Main Street. From left to right, the stores in the eastern part of the block are Lollas Brothers Shoe Repair, J. S. Lerner's Vogue, Knoepker's department store, Helzberg's Jewelry, Herm's Men's Shop, and Crown Drugs. (Harry S. Truman Library.)

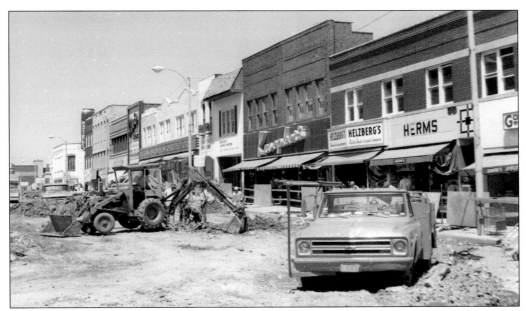

After the opening of the Blue Ridge Mall in 1958 and a flurry of annexations in the early 1960s, the town square went through a series of improvements during a revitalization program. New sidewalks, landscaping, and fountains were installed to beautify the square. Utilities were moved underground. This 1972 photograph shows some of the roadwork that was done on Maple Street as part of the Jackson Square Urban Renewal Project. (Harry S. Truman Library.)

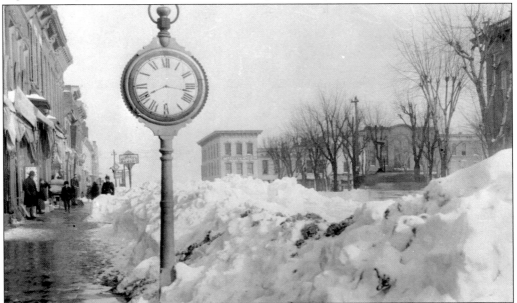

This photograph shows Maple Street looking east toward Main Street after a February 1894 snowstorm. In the distance to the right of the clock is the entire block of stores making up the east side of the square. From left to right, the businesses on Main Street are Ott's furniture store, Sampson's clothing store, Roberts hardware store, the A. J. Bundschu's Dry Goods Store, Brown's drugstore, and Soper's grocery store. (Harry S. Truman Library.)

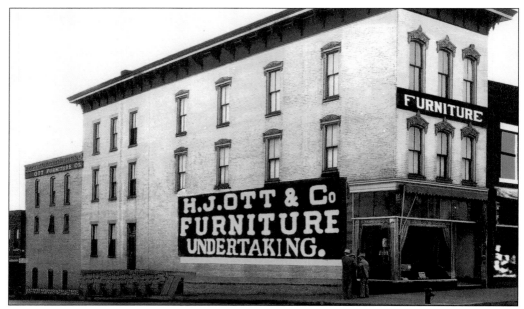

Christian Ott, an Independence resident since 1849, started his furniture store shortly after the Civil War. He and his son Henry J. Ott moved their business to the northeast corner of the square in 1884. After he sold the furniture store seen in this photograph to Charles Tucker in 1926, Christian moved his undertaking business two blocks north and established Ott and Mitchell Undertakers. (Bill Curtis.)

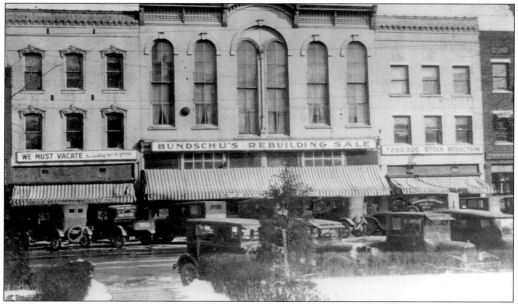

This 1928 photograph shows the Bundschu department store as it was selling off its stock before building a new store on the site. The old store was actually three buildings. The center portion was the Wilson Opera House and street-level grocery that was purchased in 1886. The left portion was the Roberts hardware store acquired in 1903. The portion on the right housed the Quincy Brown Drugstore and was purchased in 1919. (Harry S. Truman Library.)

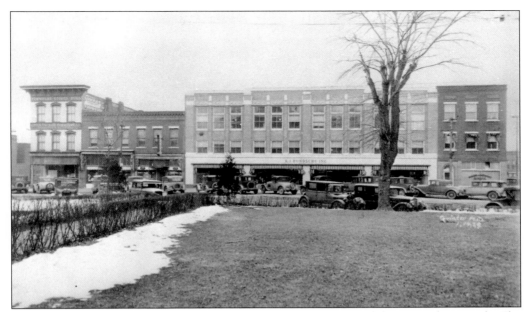

The completed Bundschu department store is seen at the center of this 1929 photograph. The building had the first public elevator, a pneumatic tube system for credit sales, and street-level lighted display windows. It was also the first fireproof building built in Independence. At the far left of the photograph is the Tucker Furniture Store, which did business at this location until 1938. (Harry S. Truman Library.)

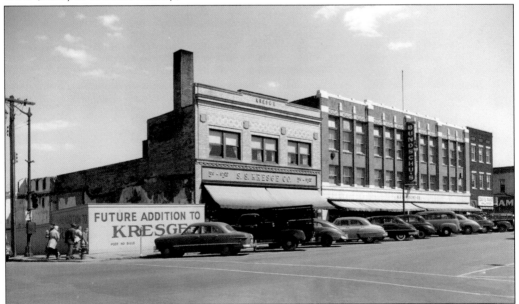

The S. S. Kresge Company bought the Sampson building on the north side of the Bundschu store in 1929. Charles Tucker relocated his furniture store to a building on Lexington Street in 1938, and his former location was destroyed by fire in 1949, when it was being used by the Save-More Drugstore. In this 1950 photograph, the Kresge store is advertising its expansion into the space once occupied by the Ott and Tucker furniture stores. (Harry S. Truman Library.)

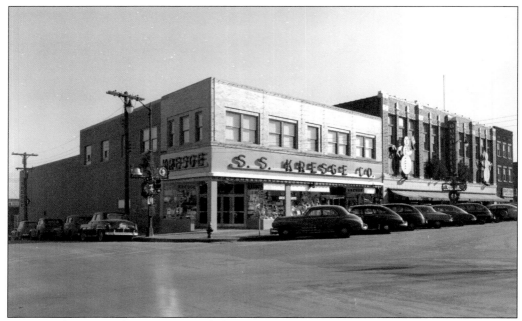

By December 1951, the expansion of the S. S. Kresge store on Main Street was completed. This store was the second Kresge outlet on the town square. The other store was two doors west of the Woolworth's Five and Dime on the north side of the courthouse square. (Harry S. Truman Library.)

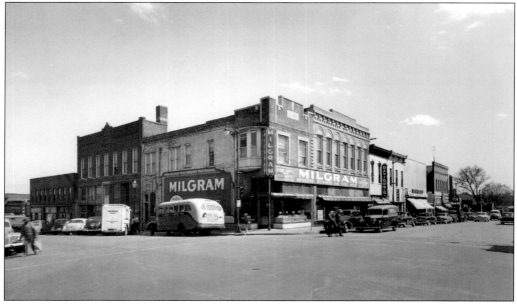

This 1950 view of Main Street is looking south across Lexington Street at the Milgram Grocery Store. The chain was established in 1914 in Kansas City, Kansas, and was known for its "Hi, Neighbor" slogan. Other stores in the block were Davidow's Ready-to-Wear, Walker's Café, Davidow's Furniture and Appliance Store, Harold Curtis's barbershop, Mueller's Appliance Store, and Store Without A Name. (Harry S. Truman Library.)

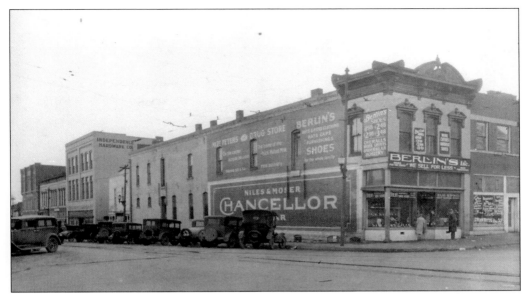

The Berlin shoe store and its 1880 building on the southwest corner of Main and Lexington Streets are seen in this 1915 photograph. In 1906, the Mize Hardware Store on Lexington Street was destroyed by fire and the store's owners bought the stock and building of the People's Union cooperative on Main Street and moved their store to that location. Mize Hardware became the Independence Hardware Company in 1912 and prospered until 1949, when the store was again destroyed by fire. (Harry S. Truman Library.)

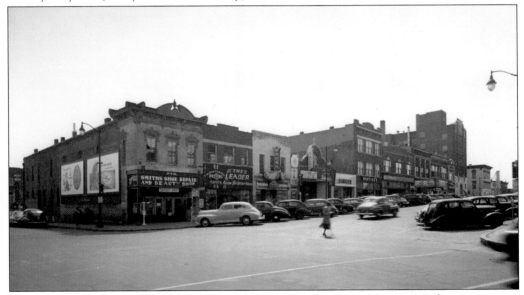

This view of the south side of the square is from 1950. The Singer Sewing Machine store next to Bunting Hardware was built after one of the frequent fires on the block. By 1951, the building housing Smith's Shoe Repair burned and was replaced by a one-story building. Other stores on this street included Brown's drugstore, Gibbon's Café, J. C. Penney's department store, Plaza Theatre, Bunyar Drugs, Moore's Fashion Shop, Cochran Music, and First National Bank. (Harry S. Truman Library.)

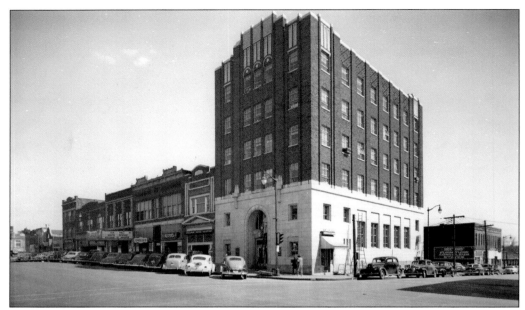

This 1950 photograph shows the First National Bank's five-story building that was constructed in 1929 on the site of its original 1874 structure. The door on the Liberty Street side of the building was an entrance to Petey Childers Prescription Shop, which operated in the building from 1933 to the mid-1950s. The offices on the upper floors of the bank building were occupied by lawyers, dentists, physicians, and insurance agents. (Harry S. Truman Library.)

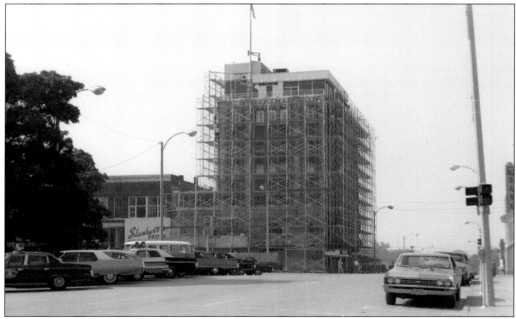

The exterior of the First National Bank building was greatly remodeled during the early 1960s. This photograph shows the scaffolding surrounding the building when it received a completely new outer surface. The exterior of the 1929 bank building still remains under the newer facade. (Harry S. Truman Library.)

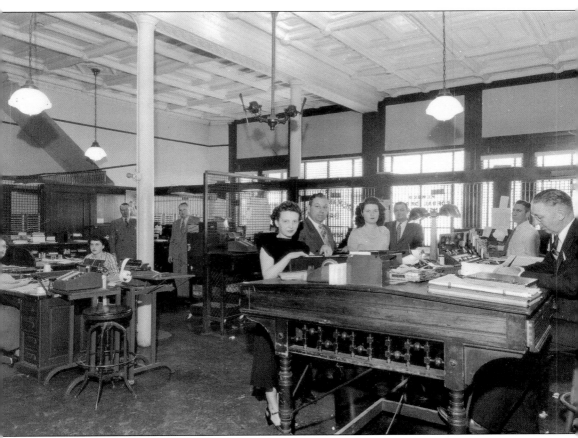

The Chrisman-Sawyer Bank, located on the corner of Lexington and Liberty Streets, was founded in 1857 and incorporated in 1877. Staff members of the bank have paused in their work for this group picture during a typical business day. A wire cage separates the bank employees from their customers in this photograph taken before the lobby and bank interior were remodeled in the late 1940s. (Phil K. Weeks family collection.)

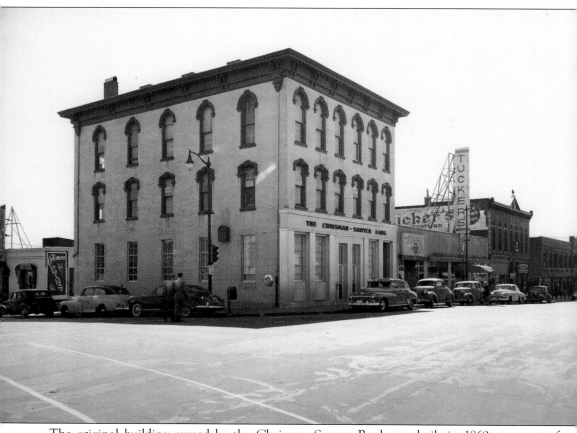

The original building owned by the Chrisman-Sawyer Bank was built in 1869 at a cost of $14,000. In this 1950 photograph, the bank is seen shortly after it was remodeled by the Weeks Construction Company. The Tucker Furniture Store, which had moved from Main Street to this location in 1938, closed in 1963. (Harry S. Truman Library.)

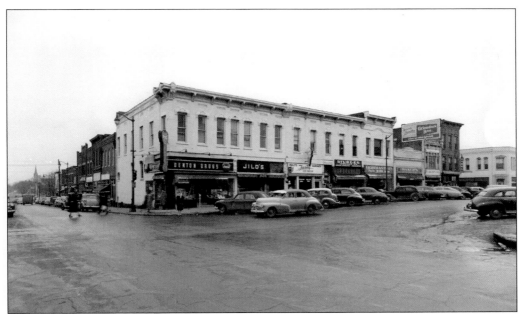

The stores that occupied Liberty Street on the west side of the square in these 1950 photographs were in the process of changing. Denton Drugs occupied the corner at Lexington and still had the Pendleton and Gentry Drugstore awning and sign in use. The other businesses were Jild's, Tasty Ice Cream, Sturges Jewelry, Bormaster's Shoes, Baker's Shoes, Charles Betts' Jewelry, and the Morris Buffet and Bar. (Harry S. Truman Library.)

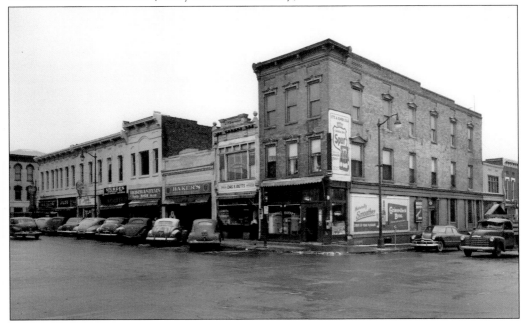

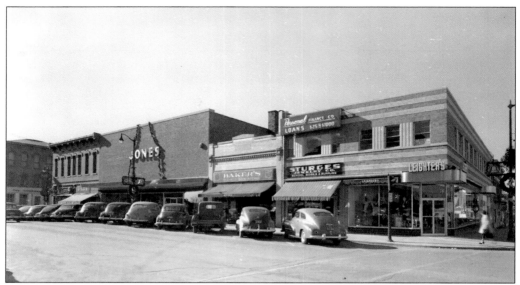

By December 1951, the Jones Store had acquired the former Tasty Ice Cream, Sturges Jewelry, and Bormaster's Shoe stores for a new department store. The Charles Betts' Jewelry and Morris Buffet and Bar buildings were razed and replaced with a Leighters women's clothing store and a new Sturges Jewelry and bookstore. Denton Drugs, Jild's, and Baker's Shoes remained on the street. (Harry S. Truman Library.)

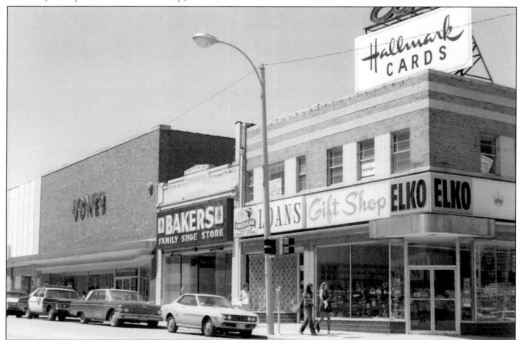

During the 1960s, the buildings along Liberty Street remained relatively unchanged, but some of their occupants did not. Sturges Jewelry, Jild's, and Leighter's clothing store were closed, and an American Loan Company and Hallmark Cards Gift Shop opened. The Jones Store and Baker's Shoes continued to attract customers. (Harry S. Truman Library.)

Four

BUSINESS AND INDUSTRY

Independence quickly became a frontier commercial center after its founding in 1827. The land surrounding the town was rich with farms, orchards, pastures, and timber. In town, the growing commerce of the prairie necessitated the development of grocers, livery stables, blacksmith shops, saddle and harness makers, wagonmakers, gunsmiths, tanners, cabinetmakers, brickmakers, carpenters, and many other businesses needed to outfit Santa Fe, Mexico, traders and emigrants going to California and Oregon. Other important early industries included foundries, flour mills, lumberyards, woolen mills, sawmills, publishers, furniture makers, and distilleries. On or around the public square were several hotels, boardinghouses, and, of course, several taverns.

By the late 1850s, Independence lost its virtual monopoly on the Santa Fe trade and wagon-trail commerce when emigrants began using nearby Westport as their point of departure. The upheaval associated with the border dispute leading up to the Civil War and the war itself had a major chilling effect on the commercial life of Independence. Many businesses closed or curtailed their operations due to the conflict, especially after the enforcement of Order No. 11 forced county residents to leave their homes, farms, and properties.

After the war, Independence began a resurgence and renewal. Brickmakers, carpenters, and other construction tradesmen built many refined homes, new schools, and businesses. The city also benefitted from new boulevards and the commuter rail service connecting Independence with Kansas City. Several key businesses were started between the Civil War and World War I, including the Waggoner-Gates Milling Company (1883), Independence Stove and Furnace (1892), the *Independence Examiner* (1898), and Independence Bottling Company (1905), and many merchants, pharmacists, and stores began doing business on the town square.

The Independence Chamber of Commerce was established in 1920 and began promoting the city as a manufacturing and trade center. In the decades of the 1920s and 1930s, the city was rich with industrial operations, such as National Aluminum and Brass, Woodcraft Equipment, May Grain Company, Good Luck Cereal Mills, Gleaner Baldwin Combine Company, Martin Chemical Company, Herald Publishing House, Middle States Rubber Company, and Friderichsen Floor and Wall Tile Company. Continued industrial and commercial growth, adaptation, and development after the Great Depression, World War II, and population changes have given Independence a solid economic base and contributed to a high quality of life.

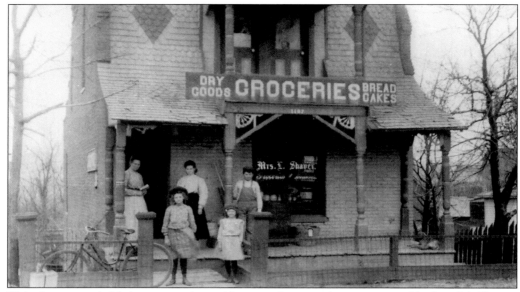

This three-story brick home was the residence and grocery business owned by Lois M. Shaver. It was located at 1107 West Walnut Street. The family lived in four rooms on the lower level, and the store occupied the street level and top floor seen here. The family members in this 1901 photograph, from left to right, are (first row) Leila Susanna Shaver and Bernice Amelia Shaver; (second row) Lois M. Shaver, Irma Louise Shaver, and Gerald Bryan Shaver. (Henrietta Jaques.)

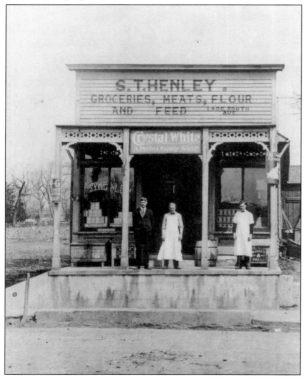

In 1901, S. T. Henley opened his grocery store at 1406 West South Avenue directly across the street from the old Chicago and Alton Railroad depot. The building was acquired by the Antoine Seed Company and razed for its new store in 1974. The men in this photograph, from left to right, are S. T. Henley, John Elsea, and Art Selby. (Joe Antoine.)

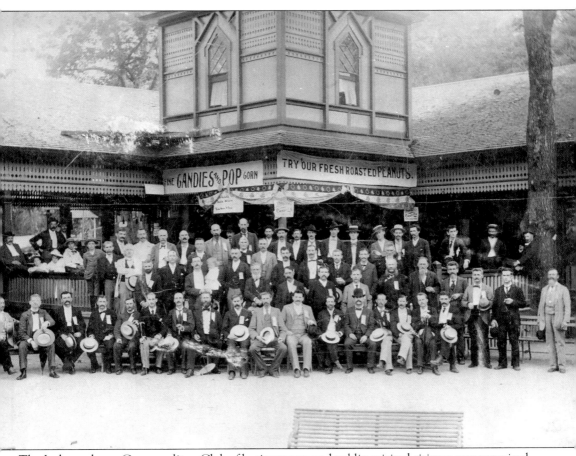

The Independence Cosmopolitan Club of businessmen and public-spirited citizens was organized in 1919 with the intent to make the town a better place to live. The group took an active interest in several civic and social problems for the short time it existed. In this 1919 photograph, the club members pose for a group portrait at Fairmount Park. (Harry S. Truman Library.)

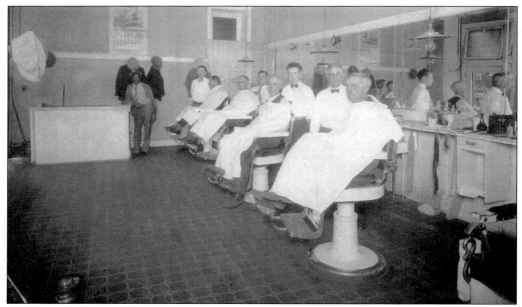

The Morman Barbershop was located near the Independence town square at 104 East Lexington Street when this photograph was taken in 1928. The four barbers serving their unidentified customers, from left to right, are Claude Eskew, Bill Morman, Walter Warner, and Virgil Morman. The man standing against the back wall of the store is Clay Claiborne. (Carolyn Roedel.)

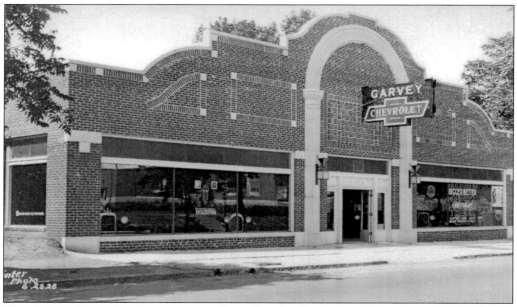

The Garvey Chevrolet Company, seen here shortly after it opened in 1928, was the first of several automobile dealerships to operate in this building. It was built on West Maple Avenue on the site of the William M. Randall house, directly across from the Soldiers and Sailors Memorial Building. Subsequent car dealers at the location included Bostian Chevrolet and Oscar Mapes Chevrolet. (Dianne Brungardt.)

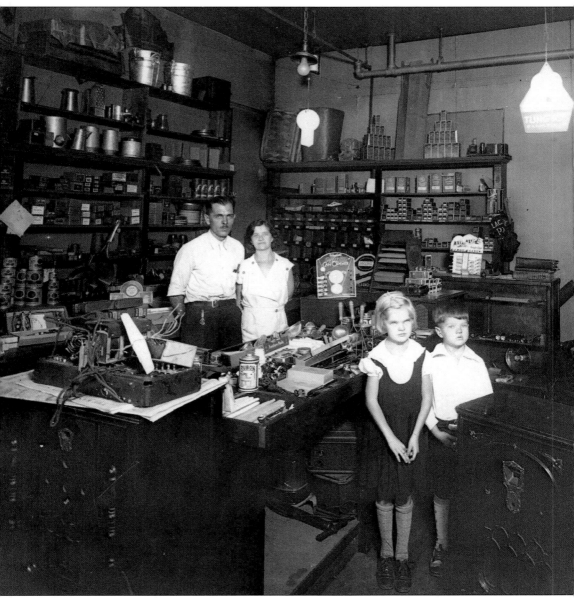

Reuel Heckart and his wife, Marguerite, operated their Maywood Hardware and Radio store on the corner of Ash Avenue and Truman Road in the 1930s. They stocked a variety of items such as Mazda lamps, steel wool, nails, screws, Tip Top razor blades, and replacement parts for radios. The children in the photograph are Mary Jo Heckart (left) and Howard Heckart. (Nancy Heckart Smith.)

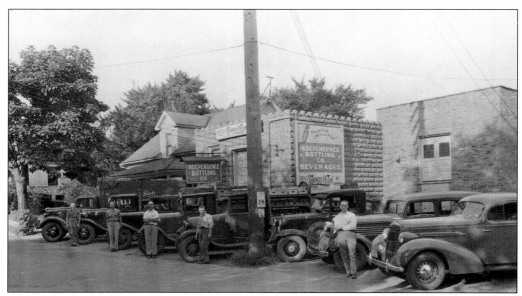

Independence Bottling Company was founded in 1905 by Kloose Wiegant, who sold the business to Louis "Polly" Compton in 1923. The company bottled Goetz Country Club Beer and the well-known Polly's Pop. The beverage company's route men are seen in this 1936 photograph. From left to right are unidentified, Victor Givan, Vernon Givan, Charlie Reed, and Compton. (Roxanne Warr Brennan.)

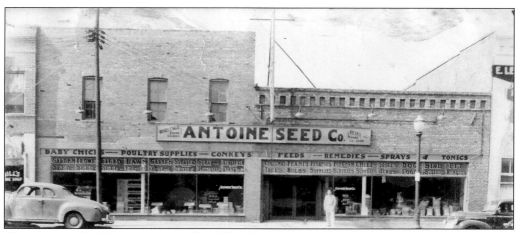

The Antoine Seed Company started in 1932 after the Antoine family acquired the T. Lee Adams Seed Company at 107 East Lexington Street. The store did business at 112 East Lexington Street from 1941 to 1974 and then moved to the corner of West South Avenue and South Crysler where they still meet their customers' needs for farm and garden seeds, pet supplies, and spices. (Joe Antoine.)

Stephenson's Apple Farm Restaurant opened in 1946 as a one-room café at Highway 40 and Lee's Summit Road. The small restaurant was adjacent to the orchard the family owned since 1870. Up to 40 patrons could eat inside the restaurant, and several others could order chicken, ribs, smoked meats, sandwiches, and desserts from the curb-service menu seen here. (Wanda Stephenson.)

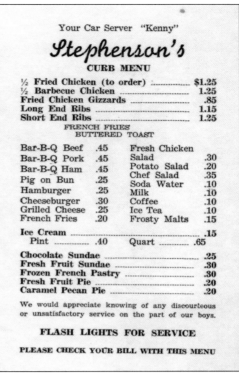

Your Car Server "Kenny"

Stephenson's
CURB MENU

½ Fried Chicken (to order)	$1.25
½ Barbecue Chicken	1.25
Fried Chicken Gizzards	.85
Long End Ribs	1.15
Short End Ribs	1.25

FRENCH FRIES
BUTTERED TOAST

Bar-B-Q Beef	.45	Fresh Chicken	
Bar-B-Q Pork	.45	Salad	.30
Bar-B-Q Ham	.45	Potato Salad	.20
Pig on Bun	.25	Chef Salad	.35
Hamburger	.25	Soda Water	.10
Cheeseburger	.30	Milk	.10
Grilled Cheese	.25	Coffee	.10
French Fries	.20	Ice Tea	.10
		Frosty Malts	.15

Ice Cream			.15
Pint	.40	Quart	.65

Chocolate Sundae	.25
Fresh Fruit Sundae	.30
Frozen French Pastry	.30
Fresh Fruit Pie	.20
Caramel Pecan Pie	.20

We would appreciate knowing of any discourteous or unsatisfactory service on the part of our boys.

FLASH LIGHTS FOR SERVICE

PLEASE CHECK YOUR BILL WITH THIS MENU

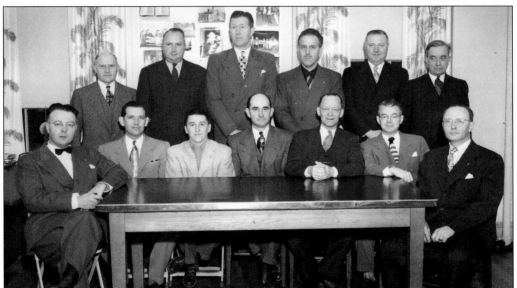

The Independence Chamber of Commerce was organized in 1920 and was an outgrowth of the work done by the Cosmopolitan Club. In 1950, members of the chamber's board of directors, from left to right, are (first row) Robert Weatherford (president), Charles Hood, Bill Austin, Earl Annis, Floyd Brown Sr., Petey Childers, and Walter Diesel; (second row) L. P. Curry, Chester Green, Oscar Mapes, Clarence Warren, Garvin Dyer, and Fleming Pendelton. (Independence Chamber of Commerce.)

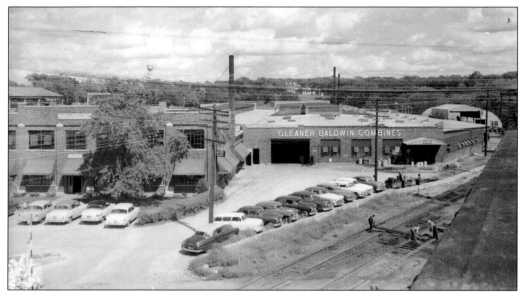

The Gleaner Baldwin Combine harvester plant on South Cottage Street was one of the major employers in Independence from 1925 through the 1950s. The plant manufactured a line of self-propelled farm implements that incorporated reaping, binding, and threshing all in one machine. In 1955, the company was acquired by the Allis-Chalmers Manufacturing Company, which was then purchased by a West German company in 1985. (Independence Chamber of Commerce.)

Independence Stove and Furnace had its beginnings in 1892, when it was founded by William Crick. The company manufactured Warm Morning furnaces and cook stoves in this plant located at the corner of South Cottage and West Hayward Streets on the opposite side of the railroad tracks from the Gleaner Baldwin Combine plant. In 1925, the business sold 10,000 stoves, 2,000 furnaces, and 750 tons of other castings. (Independence Chamber of Commerce.)

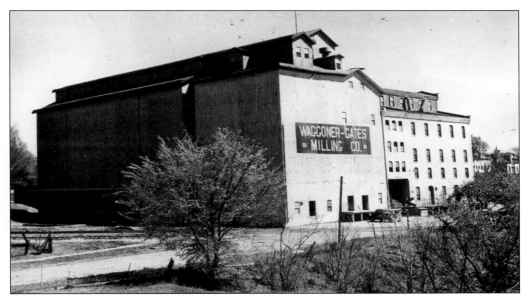

In 1866, John Overfelt sold the small gristmill he started in 1847 to Peter Waggoner, who operated it until his retirement in 1883. His son William Waggoner and his partner, George Porterfield Gates, formed the Waggoner-Gates Milling Company and continued at this South Osage Street location. The mill was one of Independence's major employers, and its Queen of the Pantry flour was popular throughout the Midwest. Most of the plant was destroyed in a 1967 explosion and fire. (Independence Chamber of Commerce.)

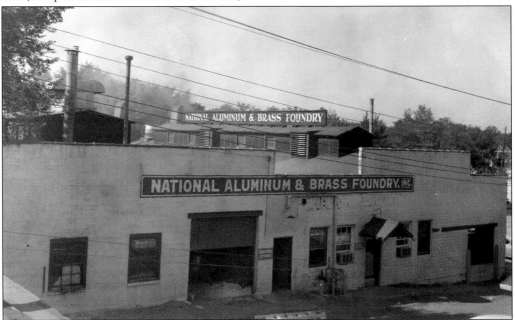

In 1921, Elbert C. Austin Sr. founded the National Aluminum and Brass Foundry on West Elm Street. The firm produced sand castings of a wide variety of metals, including copper, bronze, brass, and aluminum. In 1986, the company was purchased by Wes Kagay and Bob Fenton, who operated it until they sold it to the Ilsco Corporation. (Independence Chamber of Commerce.)

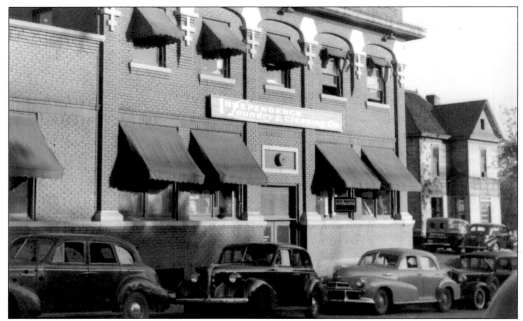

The Independence Laundry and Cleaning Company was located at 115 South Osage Street in a building that was built in 1913 on the site of Bettie Tillery's Female Academy, an 1860s finishing school for women. The building was sold in 1956 and then razed and replaced by the central professional building block of RLDS offices. (Independence Chamber of Commerce.)

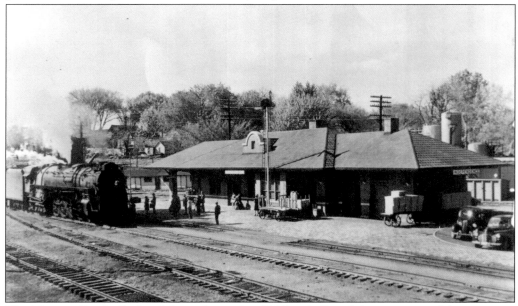

The Missouri Pacific Railroad depot, located at 600 South Grand Avenue, opened for passenger service in 1913. Harry S. Truman arrived and departed from this station during his presidency. The depot was the second on the site. The first station, a wood frame building, was moved to the northwest and used as a freight depot. From 1871 to 1913, Missouri Pacific passengers used a station located on Liberty Street near Short Street. (Harry S. Truman Library.)

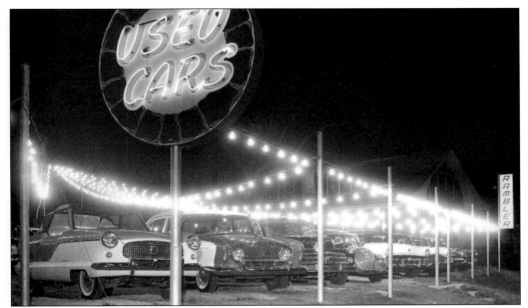

New and used Nash automobiles were sold by the Clippard-Rodekopf Packard dealership on West Lexington Street from 1953 to 1960. New cars were sold on the south side of the street in the Cook building, and this used Rambler lot was across the street. The company was located on a Winner Road site in the Englewood area from 1960 through 1974 and then moved to South Noland Road before going out of business in 1980. (Cliff Braden.)

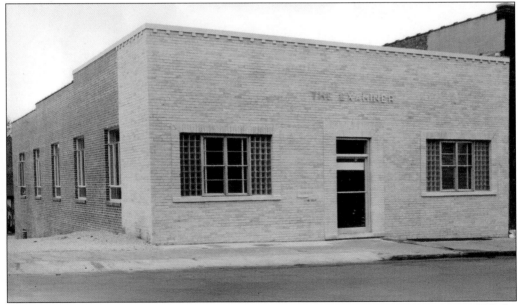

Col. William Southern began the weekly *Jackson Examiner* newspaper in 1898. In 1905, he started the daily *Independence Examiner* while still publishing the weekly edition until 1928. This photograph shows the newspaper's building at 321 West Lexington Street after it was remodeled by the Weeks Construction Company in the late 1940s. The newspaper moved to a new building on South Liberty Street in 1980. (Phil K. Weeks family collection.)

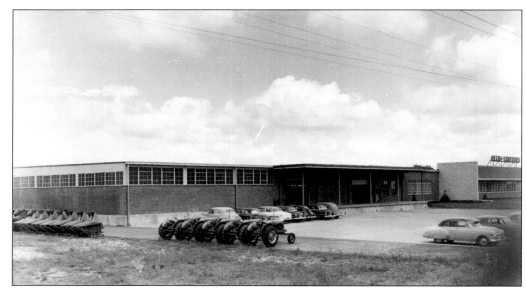

The Allis-Chalmers Manufacturing Company built tractors at this plant located at Thirty-fifth Street and Noland Road during the 1950s. The company bought the Gleaner Baldwin Combine company in 1955 and moved operations to its newly acquired plant facility on South Cottage Street. Allis-Chalmers sold its farm equipment business to K. H. Deutz AG of Germany in 1985. In 1990, Deutz sold the business to the AGCO group. (Independence Chamber of Commerce.)

Woodcraft Equipment Company was started in 1924 by Kenneth Smith, Alvin Swenson, and Orvar Swenson. The company manufactured a full line of York Archery products, including a wide variety of bows, arrows, and other archery supplies. The business was located at 1450 West Lexington Street in this plant, a former canning factory. (Independence Chamber of Commerce.)

Sudora's Beauty Salon and Children's Wear specialized in hair styling and sold Bonne Bell and Dermetics Cosmetics and clothing for infants through teenagers. The store, owned by Susan L. Matthew and Dora M. Perkins, was located at 215 North Main Street in the building that had been occupied by the Electric Theater movie house during the second decade of the 20th century through the 1940s. (Phil K. Weeks family collection.)

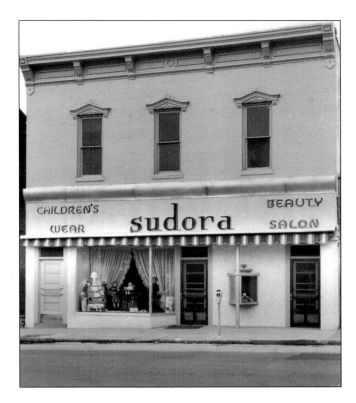

The Chicago and Alton Railroad depot was built in 1878 on West South Avenue on the west side of Crysler Avenue. Over the years, several railroads owned the station and trackage rights. The Gulf, Mobile and Ohio Railroad was the last to provide passenger service through the depot. This photograph shows a one-way ticket for the very last passenger train to stop at the station. The depot was completely abandoned in 1972. (Marvin Sands.)

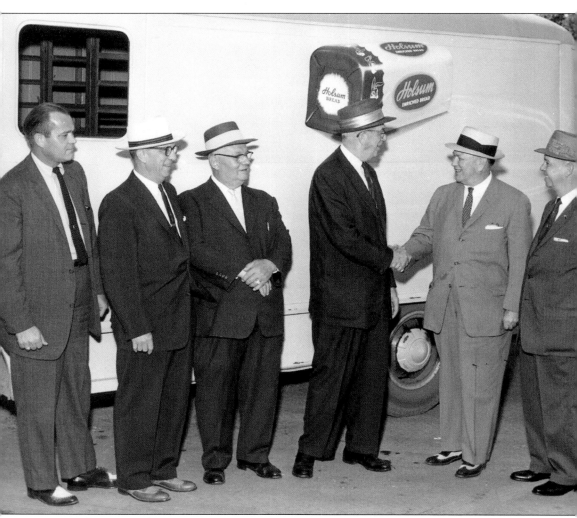

According to its slogan, Holsum Bread was "fresh and sweet and good to eat." Members of the Independence Chamber of Commerce welcomed the opening of the Holsum Bakery Distribution Center in 1959. Celebrating the new business, from left to right, are Doc Hutton, Coburn Jones, Joe Cirese, C. J. Patterson, Mayor William Sermon, and Judge Snyder. (Independence Chamber of Commerce.)

Five

BUILDING SOUND MINDS

Before the Civil War, the only formal education for children available in Independence was provided by private subscription schools. In these programs, parents paid for their children's attendance, usually with meat, produce, or furs. Several early academies were established during the 1830s, 1840s, and 1850s, but these usually failed within two or three years. Those that did succeed, such as Rev. William H. Lewis's seminary and Bettie Tillery's Female Academy, closed at the start of the Civil War and struggled after the war or did not resume operations.

After the Civil War, the Missouri legislature required public schools to be provided in areas with enough students to support them. The Independence School District was created in September 1866 when six men were elected to the first school board. The board selected a superintendent, set salaries for teachers, and rented classrooms for students. The school district purchased the old Lewis seminary building in 1867. Caucasian students attended classes in eight grades in the newly acquired facility while black children attended two grades in rented rooms before the school board had a separate school built for them in 1870.

The Independence School District added several school buildings during the 1880s and 1890s. Ott School and Noland School were built in 1885. Columbian School opened in 1892, and a new Independence High School building began service in 1898. Benton (1903), Bryant (1913), and McCoy (1914) Schools were opened early in the 1900s. The first William Chrisman High School was built in 1918. Several other schools were constructed in the city, as old buildings were destroyed by fire, demolished for construction projects, or necessitated by population shifts.

Three short-lived colleges also were located in the town in the early years. Woodland College was established in 1869 as a women's college, became coeducational in 1880, and ceased operations in 1901. Independence Female College, also known as Presbyterian College, opened in 1871 and closed in 1905. The St. Mary's Convent School was started in 1878 and has been in continuous operation, in one form or another, as an academy, grade school, and high school.

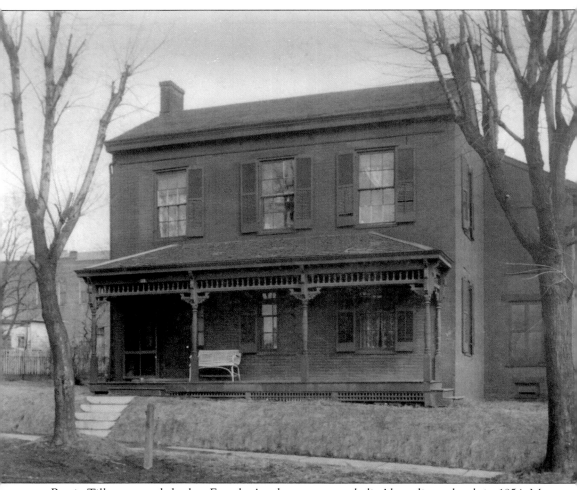

Bettie Tillery started the her Female Academy, a young ladies' boarding school, in 1854. Many of the best-known women in town attended her school in this brick building on South Osage Street. She closed the school during the Civil War and reopened with little success after the conflict. She then taught in the town's public school until 1875. The academy building was razed in 1912. (Harry S. Truman Library.)

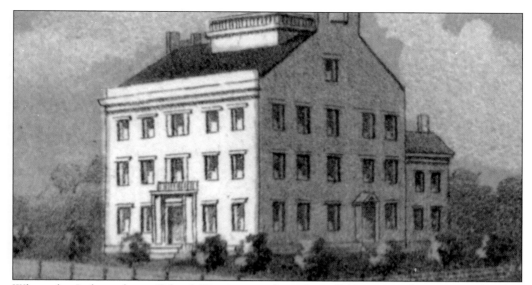

When the Independence School District was formed in 1866, it rented rooms in churches for classrooms. Built on Liberty and College Streets in 1854, the school board bought this seminary from Rev. William H. Lewis in 1867 for $11,000 to serve 1,152 school-age children. Monthly salaries for the 10 instructors employed by the district were $75 for principal teachers, $50 for assistant teachers, and $100 for the superintendent. Curriculum included orthography, reading, writing, geography, history, grammar, and music. (Library of Congress, Geography and Maps Division.)

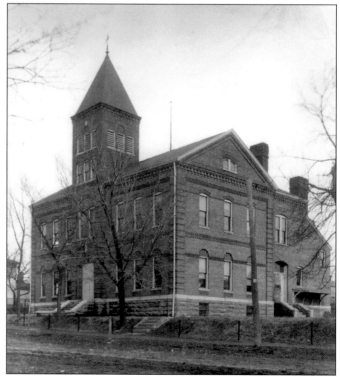

Noland School was built in 1885 on a lot on South Liberty Street near Pacific Street. The six-room brick building was named after Hinton H. Noland, who had served on the Independence School Board from 1879 to 1894. Young Harry S. Truman attended this school when he was in first and second grade. The school, seen in this 1904 picture, was razed in 1935. (Harry S. Truman Library.)

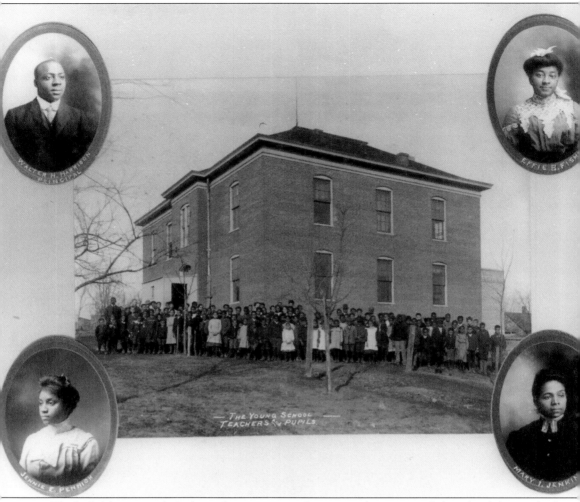

The Young School
Teachers & Pupils

Black children in early Independence were taught in rented rooms until the school district built a separate school for them. In 1874, the Independence School District spent $2,500 to build and furnish this eight-room schoolhouse, located between East Waldo and East Farmer Streets, for use by black students. The building was originally named after the great abolitionist Frederick Douglass. When Hiram Young died in 1882, the school was renamed to honor the former slave who purchased his freedom and conducted a large wagon-and-yoke-building business in Independence. (Harry S. Truman Library.)

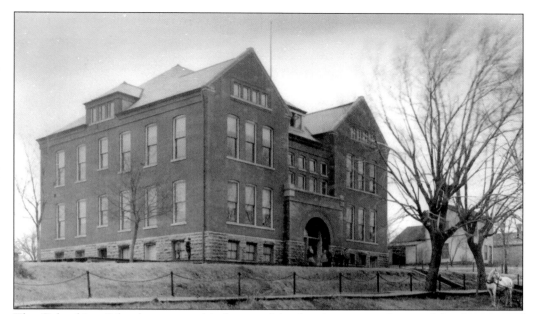

The Columbian School was named in honor of the fourth centennial year of the discovery of America by Christopher Columbus. The building, designed and built by Christian Yetter and Robert McBride, had eight classrooms when it was erected in 1892 at a cost of $9,000. This photograph was taken in 1904, three years before a four-room annex was built. The school was razed in 1936. (Harry S. Truman Library.)

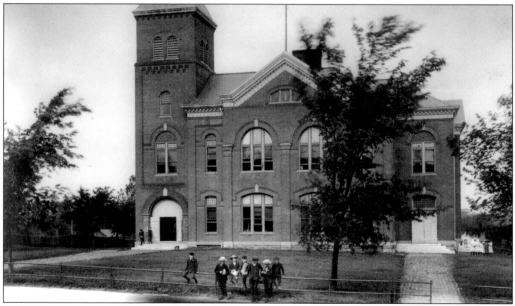

In 1885, the seminary building that the Independence School District bought in 1867 was torn down and replaced by a 10-room brick school on the same site. The school was named in honor of Christian Ott, a school board member from 1878 to 1892. This building was razed in 1935 and rebuilt that same year at Noland Road and Highway 24. In 1955, a new Ott School was built on North Noland Road. (Harry S. Truman Library.)

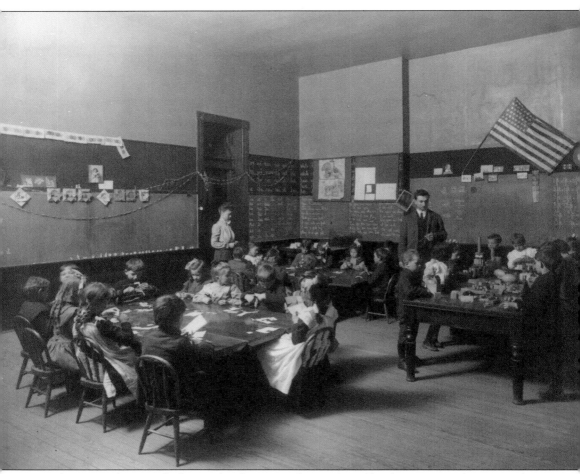

This 1904 photograph shows a kindergarten class at Ott School. Twenty students seated at two tables are working with scissors and construction paper, while nine other children stand at a taller table filled with three-dimensional shapes and blocks. The writing on the chalkboard is typical for grammar and math lessons. A 45-star American flag is prominently displayed on the wall. (Harry S. Truman Library.)

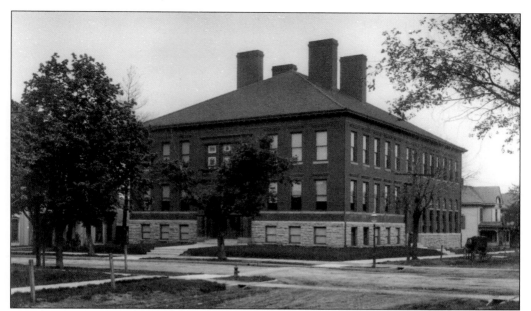

Independence High School on the corner of Maple and Pleasant Streets was built in 1898 at a cost of $30,000. The building had 12 classrooms and an auditorium that seated 600. It was called Central High School from 1898 to 1908, the year a library addition opened. It became a junior high school in 1919, when the first William Chrisman High School opened. The building was destroyed by fire in 1939. (Independence School District.)

Benton School was named in honor of Missouri statesman Thomas Hart Benton. It cost $10,600 when it was built in 1903. The building had eight classrooms and was constructed in the popular box style of the day with all rooms being about the same size. The building was condemned in 1951, and a new Benton School was built on South Leslie Street. The new building was enlarged in 1964. (Independence School District.)

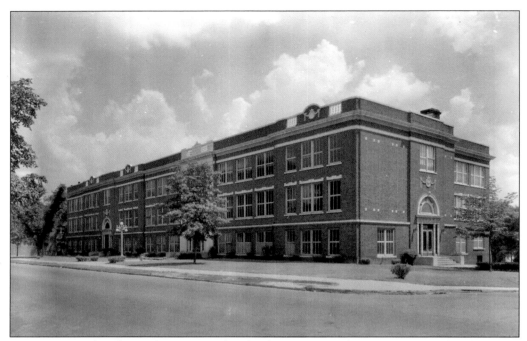

Construction of William Chrisman High School on West Maple Street was completed in 1919; an annex was added to the building in 1928. The building became a junior high school in 1958 after a new William Chrisman High School opened on North Noland Road. (Harry S. Truman Library.)

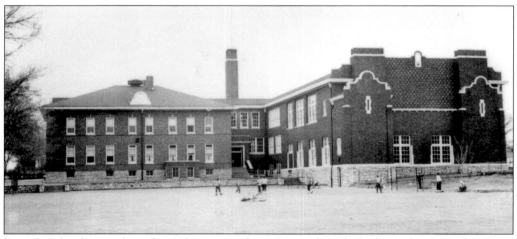

Bristol School served students living in the Maywood and Englewood areas of western Independence. It was a Jackson County common school in 1897 before it was annexed by the Kansas City School District in 1911. This picture shows the entire school, including the 1924 addition, as it was in 1949. The building was razed in 1987, and a post office was constructed on the site. (Bill Latta.)

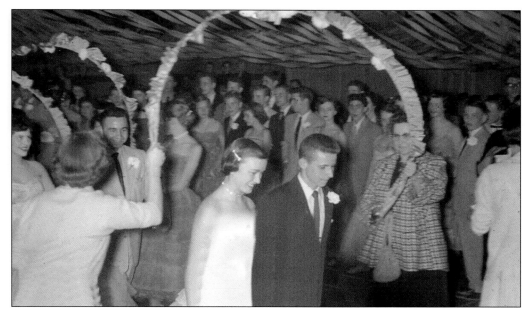

Bristol Teen Town was started in 1946 and held in the school gymnasium until Van Horn High School opened in 1955. The weekly programs included talent nights, sock hops, and theme dances, such as the St. Valentine's Day Sweetheart Dance seen in this photograph. The first two couples walking under the decorated arches are Jane Klein with Jim Tucker followed by Nancy Jodts with Dan Woodall. (Joe Klein.)

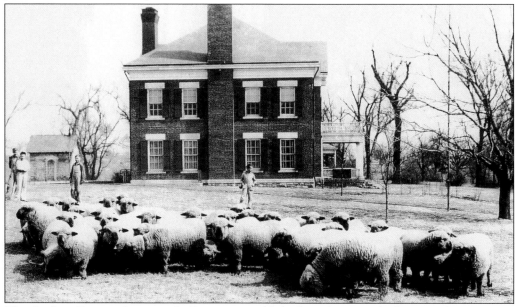

The Andrew Drumm Institute for Boys was established as a home and educational program for orphaned and indigent boys in 1928. The young boys attended Independence schools for most of their academic needs and received vocational-agricultural training at the 372-acre farm. In this 1932 photograph, a group of registered Hampshire rams patrol the grounds on the west side of Beals Hall. (Bill Roberts.)

Alton Elementary School was built in 1925. It was named for the street on which it was located, which is now better known as Twenty-third Street. A large classroom wing was added to the rear of the building in 1953. This picture was taken in the late 1960s and shows the front of the building as it faced Twenty-third Street. The school district sold the building in the 1970s, and it is now owned by the Restoration RLDS church. (Independence School District.)

Thirty new classrooms were added to the old Independence High School on the corner of Maple and Pleasant Streets in 1930, when it was being used as a junior high school. In 1939, the old part of the building was destroyed by fire, and 14 special classrooms and laboratories were added in 1940. This new building was named Palmer Junior High School in honor of former superintendent W. L. E. Palmer and his wife, Ardelia. (Phil Weeks family collection.)

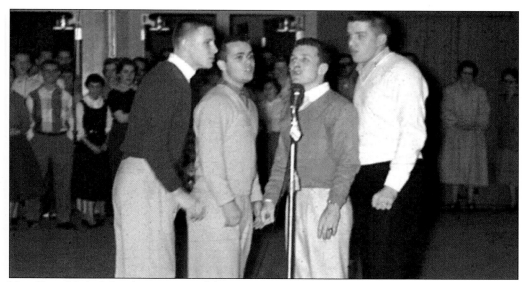

Van Horn High School was a part of the Kansas City Public School District when it opened in 1955. The school, located at 1109 Arlington Avenue in western Independence, served students living in the Englewood, Maywood, Fairmount, and Sugar Creek areas. The Gloom Chasers perform at a teen town dance in the Van Horn High School gymnasium in 1956 or 1957. From left to right, the four men in the group are Ron Turner, Ralph Sheets, Jim Evans, and Ross Arnold. Teenagers from Van Horn, William Chrisman, East, and Northeast High Schools attended these dances. (Joe Klein.)

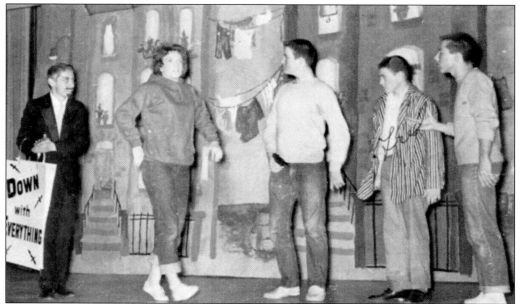

The performing arts were an important part of the educational program at Van Horn High School. From left to right, the students performing in the school's 1961 Vantasia production of *The Hither and Thither of Danny Dither* are Morris Epperson, Marilyn Kilpatrick, Richard Piland, Fred Hendrix, and Larry Dickson. The two faculty members who directed the production were William Cofer and Robert Klamm. (Richard N. Piland.)

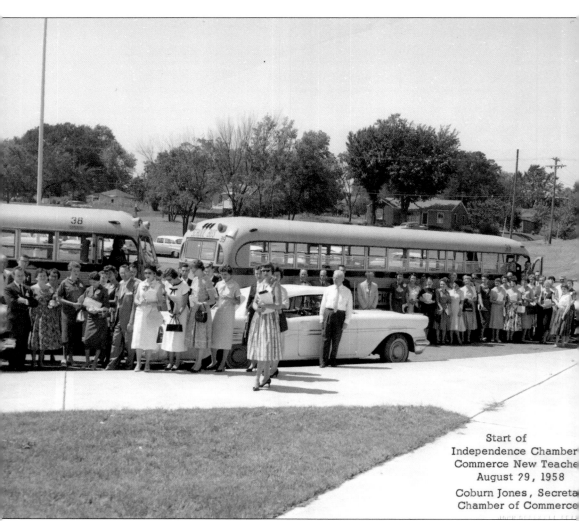

New teachers hired to serve in the Independence School District during the 1958–1959 academic year were given a tour of points of interest around the community and visited the Harry S. Truman Library during an orientation program organized by the Independence Chamber of Commerce. Many of the teachers were on their first assignment, and most were from outside the community. (Independence Chamber of Commerce.)

Six

TENDING SOULS

Not all early residents of Independence were religiously inclined. Life was harsh, and survival was a hard struggle. The majority of settlers, however, did have religious sentiment, and the diversity of the pioneers made possible a rich religious history shared by several different faiths. Initially church groups gathered in open fields or private homes for worship. Preachers were not salaried clergymen; they were more likely merchants or farmers who worked their fields every day. Some denominations, however, did have circuit preachers. Early houses of worship were log structures that were frequently replaced by frame buildings, and those were replaced in many cases by impressive brick churches.

The earliest congregations to be organized or established in Independence were the Church of Christ in 1830, the Cumberland Presbyterian Church in 1832, the Methodist Church (South) in 1835, the Christian Church in 1836, the First Presbyterian Church (Old School) in 1841, and the Church of the Holy Cross, subsequently renamed St. Mary's Catholic Church in 1849. Many local residents did not accept or tolerate members of the Church of Christ and their antislavery views. Substantial unrest developed, and the town's residents drove the Mormons from the county in 1833.

Advances in religion and churches were made from 1845 to 1855 and then during the years after the Civil War. The Baptist congregation formed in 1851, followed by the African Baptist Church in 1864 and the African Methodist Episcopal Church in 1865. Many denominations experienced dissension and divisions as a result of the war and split into north and south factions.

In 1873, the denomination of the RLDS headed by Joseph Smith III returned to Independence and established its world headquarters near the original temple lot that had been dedicated by the Church of Christ in 1831. The RLDS church built its Stone Church in 1888 and started construction of the auditorium in 1926.

Over the years, religious diversity in Independence has grown as the town has. Today the city is home to more than 120 churches representing more than three dozen denominations of faith.

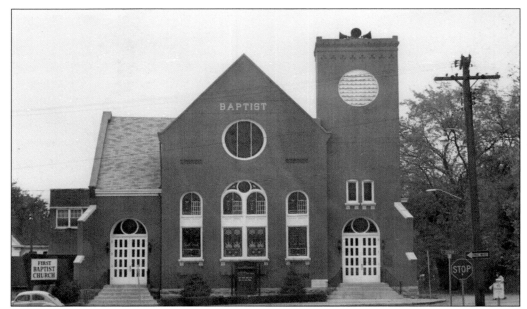

The First Baptist Church congregation was organized in 1851 and built its first brick church building in 1856. That structure was destroyed by fire and replaced in 1895 by the building on Truman Road seen in this photograph. A Sunday school annex was built at the rear of the church in 1922. There have been several other additions and expansions of the church over the years. (Harry S. Truman Library.)

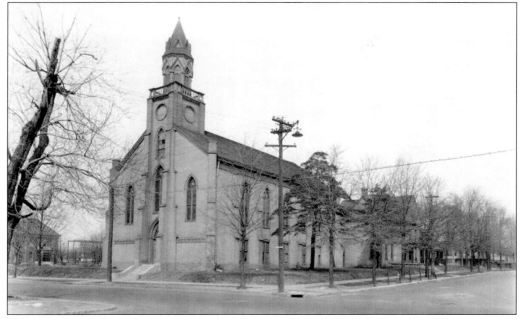

This photograph shows the First Methodist Episcopal Church located at Maple and Spring Streets as it was in the 1920s. The church was organized as a Methodist Church South congregation in 1835. The two-story brick building and its 70-foot tower were completed in 1859. (Harry S. Truman Library.)

The congregation of the First Presbyterian Church dates from 1826. The church building seen in this photograph was built at the corner of Lexington and Pleasant Streets in 1888 on land the church bought from William Chrisman. In 1924, an education wing was added to the west side of the church. The building went through a major restoration in the 1970s. Eight-year-old Harry S. Truman met Bess Wallace while attending the church's Sunday school in 1892. (Richard N. Piland.)

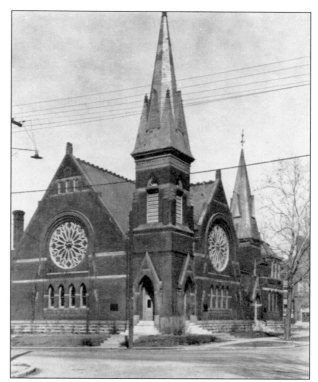

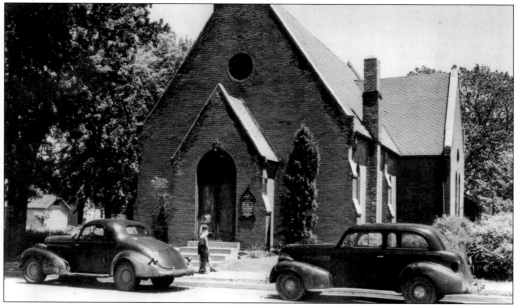

An 1877 tornado destroyed the wooden church on South Main Street that first housed the Trinity Episcopal Church congregation that was organized in 1844. This Victorian Gothic–style church was designed by prominent architect John Hubbard Sturgis for the congregation and built on North Liberty Street in 1881. Truman and Wallace were married in this church in 1919, as was their daughter Margaret and Clifton Daniel in 1956. (Harry S. Truman Library.)

The Cumberland Presbyterian Church in Independence was formed in 1832. The congregation replaced its wood frame church with a brick structure in 1847 and enlarged that building in 1859. This photograph shows the new church that was built for the congregation in 1898 at the same location on North Liberty Street. The RLDS purchased this church in 1920. The building was razed when Truman Road was widened in the 1950s. (Marietta Wilson Boenker.)

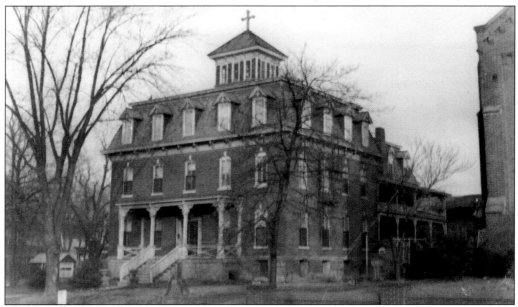

The nearly square building housing the St. Mary's Convent for the Sisters of Mercy was built on North Liberty Street in 1878. The extension at the rear of the building was added in 1904 to help meet the needs of grade-school classes held at the convent. The corner of St. Mary's Catholic Church can be seen at the far right of the photograph. The convent was razed in 1959, and a new convent was dedicated in 1961. (Kansas City Diocese Historical Archives.)

The church in this photograph was built in 1910 for the congregation of the German Evangelical St. Lucas Church, a group that was organized in 1878. This building, known as the Rock Church, was located at the corner of Main and Farmer Streets. The church building was first sold to the Assembly of God in 1957 and then to St. Mary's Catholic Church, which used it as a parish hall until 1984, when it was razed. (Kansas City Diocese Historical Archives.)

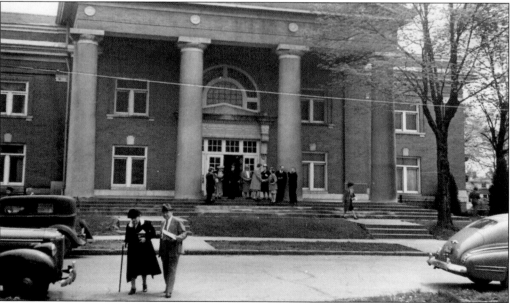

The First Christian Church has had several buildings at its site near the corner of Pleasant and Kansas Streets. The first church was built in 1836, the year the congregation was established. The second building was completed in 1854 and remodeled in 1874. The third building, designed by architect John F. Felt and built in 1909, burned in 1918. Seen in this photograph is the rebuilt church as it was in 1919. (Harry S. Truman Library.)

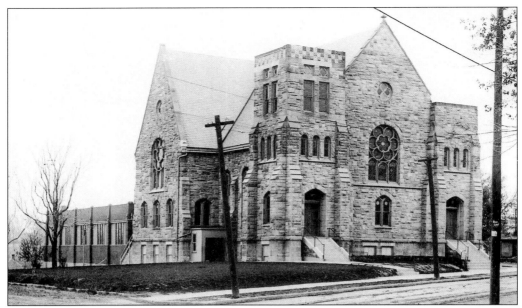

Construction of the Stone Church, the mother church of the RLDS in Independence, was started in 1888. The church's congregation was organized in 1873, 40 years after the group of earlier Mormons had been forcibly expelled from Jackson County. The church's left tower was originally designed to be much taller with a pointed steeple. In 1892, the church's steeply pitched roof was completed. (Gary Christina.)

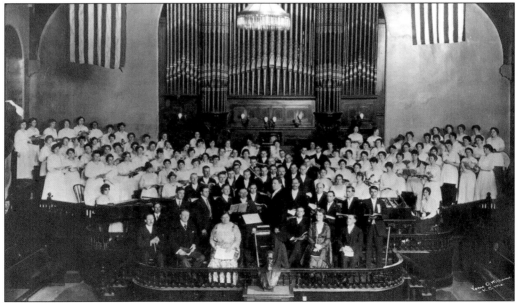

More than 130 people performed Georg Friedrich Handel's *Messiah* at the Stone Church on April 13, 1916. This was the first *Messiah* choir performance that became an Independence tradition. From left to right, the performers in the first row include B. R. McGuire; George Deane, tenor; Mrs. Wallace Robinson, soprano; Albert N. Hoxie, director; Ed Bell; Ethel Kinnamon, contralto; and Paul N. Craig, bass. (Community of Christ Library Archives.)

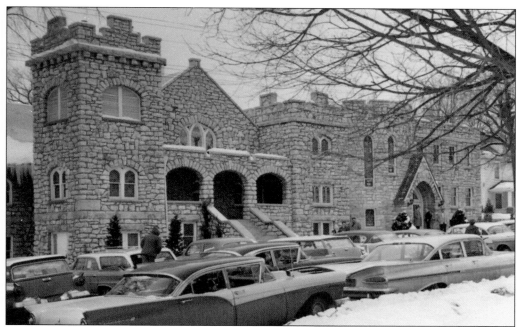

The Mount Washington Methodist Church was founded in 1893 in the intercity district between Kansas City and Independence. The congregation built the left half of this grey limestone church on Arlington Avenue north of Highway 24 in 1908. This 1959 photograph shows the original structure and the gymnasium and Sunday school rooms, which were added to the north side of the church in 1928. The Mount Washington area was annexed by Independence in 1961. (Marilyn Kilpatrick West.)

Workers of the Weeks Construction Company begin clearing the land to start construction of the RLDS auditorium in February 1926. The white two-story building in the background is the Hendrickite Church of Christ, which is on another part of the original temple lot dedicated by Joseph Smith in 1831. This church was burned down by arsonist William Pattyson in 1898, rebuilt in 1902, destroyed by fire again in 1990, and rebuilt again in 1992. (Phil K. Weeks family collection.)

The primary excavation for the auditorium is nearly complete as mules and men continue work to pull away loads of the remaining soil during August 1926. The building at the far left of the photograph is the Columbian School, built in 1892 and enlarged in 1907. The Independence Board of Education sold the school to the RLDS church in 1934. Two years later, the school was razed to make way for the auditorium. (Phil K. Weeks family collection.)

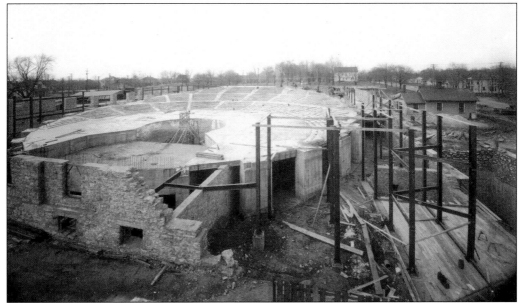

Reinforced concrete for the first floor was poured for the large assembly room in the lower part of the auditorium by the early spring of 1927. Even though the building was far from complete, the basement was finished enough, heated, and equipped to house the RLDS General Conference of 1927. At the meeting, church leaders decided to borrow additional funds to protect what had already been built and continue construction. (Phil K. Weeks family collection.)

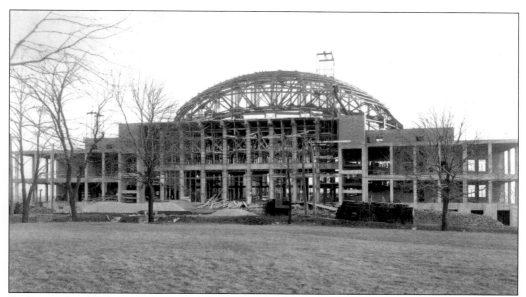

By September 1928, construction of the auditorium had progressed enough that members of the general quorums, church officers, and departments moved their offices to the building. The basic structure of the building was in place, and the dome roof covered the general assembly hall. With construction costs exceeding the original estimate of $750,000 and augmented by the $335,000 bonds authorized in 1927, the church was deeply in debt. The Depression of the 1930s also affected the church. Construction of the auditorium stopped in January 1931, and the church initiated policies of retrenchment, including having additional construction work proceed on a cash-in-hand basis. (Above, Phil K. Weeks family collection; below, Mary Charlotte Gamel.)

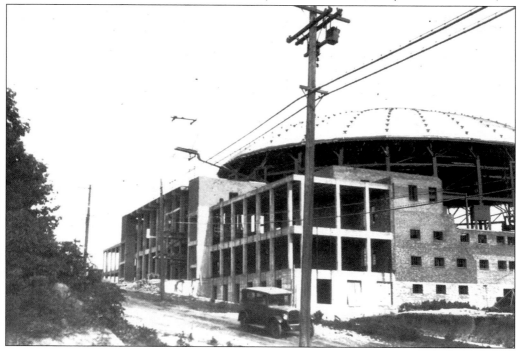

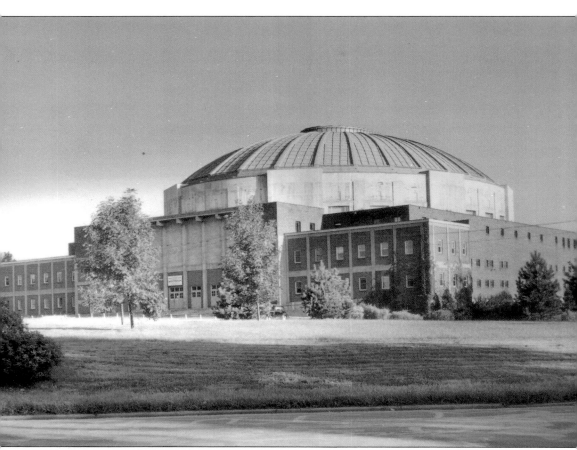

Construction of the auditorium was completed in 1958 at a cost of $4 million. Nearly 1,200 congregations throughout the world provided the funds for the building, and it was completely debt-free when it was dedicated in 1962. The structure measures 250 by 270 feet and is 130 feet high. The dominant feature is the 211-foot free-span dome that is 92 feet above the 5,800-seat assembly hall floor. The exterior of the dome is copper, painted green, and 114 feet above street level. There are 200 rooms that are used by church officers and departments such as religious education, music, radio, audiovisual, public relations, and building maintenance. A banquet hall can seat 600 and serve 1,000 persons an hour cafeteria style. The auditorium houses a world-famous Aeolian-Skinner pipe organ that contains nine divisions, 113 ranks, and 6,334 pipes ranging in length from one-quarter of an inch to 32 feet. The organ, installed in 1959, is one of the 75 largest pipe organs in the world. (Phil K. Weeks family collection.)

This Colonial-style church on South Pleasant Street was built for the First Church of Christ, Scientist, in 1942. The congregation was organized in 1906 and met in a variety of locations, including the old Cumberland Presbyterian Church on North Liberty Street from 1914 to 1917. In 1986, the Independence congregation united with the Fourth Church of Christ, Scientist, in Kansas City and sold this building to another church. (Harry S. Truman Library.)

The Waldo Avenue Baptist Church congregation, after several years of growth and expansion, was proud of its newly remodeled choir loft, pulpit, and building addition in the early 1940s. The church was destroyed by fire in 1978. It was rebuilt on the same site, but the church and Christian school the congregation owned became defunct in the 1990s. (Phil K. Weeks family collection.)

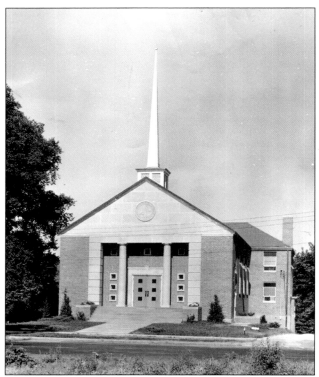

The Cumberland Presbyterian Church on Liberty Street was purchased by an RLDS mission group in 1920. The Liberty Street mission that bought the building was formed in 1914. After the church building was razed in the 1950s, the congregation built the church seen in this photograph at 416 North Liberty Street and continued to keep its Liberty Street Community of Christ name. (Phil K. Weeks family collection.)

Several funeral homes have served the needs of Independence residents. The Carson Funeral Home handled the private services for the Truman family after the former president's death in 1972. The pictured remembrance card is for William H. Norton (1912–1975), who owned and operated the Independence Window Cleaning Company. (Richard N. Piland.)

Seven

LIFESTYLES

Independence has provided its citizens a wide variety of opportunities to have the lifestyles they preferred. For most residents, their families and the community's churches, schools, businesses, and neighborhoods have been the focus of their life.

Independence has many homes throughout the city reflecting a variety of architectural styles. There are several excellent examples of Queen Anne–style homes, including the Bellene-Choplin, Bryant, and Hughes-Childers homes built in the 1880s and 1890s. This style of architecture helped Independence become known as the "royal suburb" of Kansas City during the late 19th century. Other homes built in the Second Empire–style, including the Porter-Chiles home and the unique Vaile mansion, are well known throughout the community. The diversity in architectural styles includes special examples of the Italianate, French Renaissance, side hall plan, American foursquare, prairie style, and antebellum homes.

Community-wide activities have been staged for many years. During the early 1900s, annual fairs with horse races, contests, and competitions were held at the Independence Fair Grounds from 1906 to 1924. Starting in 1912 and for several years afterward, community residents could attend summer chautauqua programs. There have been many fraternal groups that have worked for the betterment of the community as well as provide for the social needs of their members. Young people have participated in community-wide Scouting programs since 1910. The first Santa-Cali-Gon Trails Festival honoring the city's role in the westward expansion of the country occurred in 1940. The festival has become an annual tradition since 1974.

Music, theater, athletics, and art have been Independence pastimes over the years. During the early history of Independence, music and theater performances were given at the Wilson Opera House and the music hall. Several buildings on the town square also had large meeting rooms on their upper floors, and a variety of entertainments were held in them. Starting in 1916, one of the musical highlights of most years has been the performance of Georg Friedrich Handel's *Messiah* at the Community of Christ auditorium. School choirs and performances by groups such as Sweet Adelines have been well supported by residents. The memorial building stage has frequently been used for a variety of performances. The city has had movie houses such as the Plaza, Electric, Granada, Englewood, and Maywood theaters and, in more recent years, drive-in theaters. Many sports-oriented activities have also played an important role for residents.

Fairmount Park was a popular recreational area for Independence and Kansas City residents from its opening in 1893 through the 1930s. The 50-acre park, located between Northern Boulevard and Sterling Avenue north of Highway 24, had a large lake, a golf course, an amphitheater, a bandstand, picnic areas, and amusement park rides. This 1906 photograph shows the interior of the pavilion that could seat several hundred people. (Library of Congress, Prints and Photographs Division.)

The Independence Fair Association was formed in 1906 to organize the first big fair held in town since 1872. The fairgrounds east of Noland Road near Alton Avenue featured a grandstand that could seat 1,000 people and the half-mile racetrack seen in this 1909 photograph. Activities at the grounds included horse and car racing; baseball and football games; arts and agricultural shows; and airplane exhibitions. Fairs were held annually from 1906 to 1924, when the grounds were sold for a housing development. (Harry S. Truman Library.)

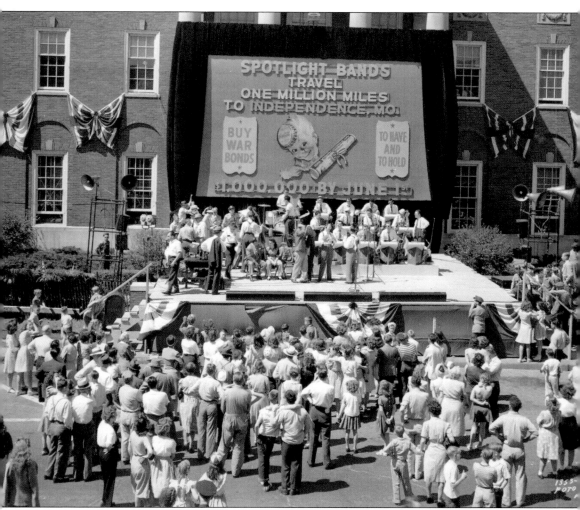

The Tommy Tucker Orchestra entertained Independence residents, a national Blue Network radio audience, and Armed Forces Radio Service listeners when it played at the courthouse in 1945. The band was in town as part of the Victory Parade of Spotlight Bands program sponsored by Coca-Cola. The program featured singer Don Brown, the Three Two-Timers, Kerwin Somerville, and the Tommy Tucker Orchestra playing its 1941 hit, "I Don't Want to Set the World on Fire." (Independence Chamber of Commerce.)

The first Santa-Cali-Gon Trails Festival was held in Independence over three days during October 1940. The celebration included an opening-day parade, Western rodeo, festival queen contest, and hundreds of costumed participants. This image shows the back cover of the souvenir edition of the *Jackson County Picture Digest*, one of the festival's programs. (Bob Potter.)

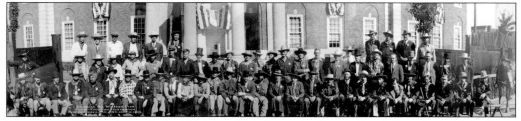

More than 60 members of the Whisker Club from the Sugar Creek Standard Oil Refinery pose in front of the Jackson County Courthouse during the 1940 Santa-Cali-Gon celebration. The club was just one of several groups that participated in the first festival. Although the 1940 festival was a success, it was seven years until another was staged. In 1947, the second festival was a three-day affair held in mid-September. In 1973, the city organized a Three Trails Days celebration to showcase the renovations made in the town square. In 1974, the festival was renamed the Santa-Cali-Gon Trails Festival and is now held annually during Labor Day weekend. (Independence Chamber of Commerce.)

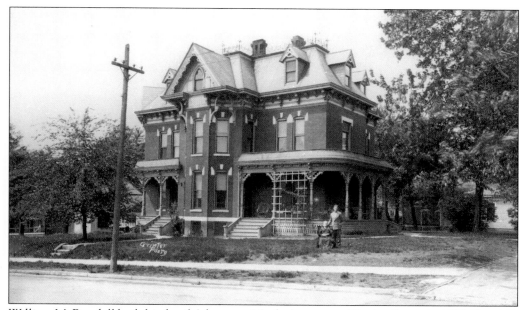

William M. Randall built his family's home at Maple Avenue and Spring Street in 1888. Randall, Independence's leading brick mason from 1856 to his death in 1907, and his two sons built nearly every important building in Independence during those years. His grandson former congressman William J. Randall stands on the lawn next to Laura Harris Bridges, the representative's maternal grandmother. The house was razed in 1928. (Dianne Brungardt.)

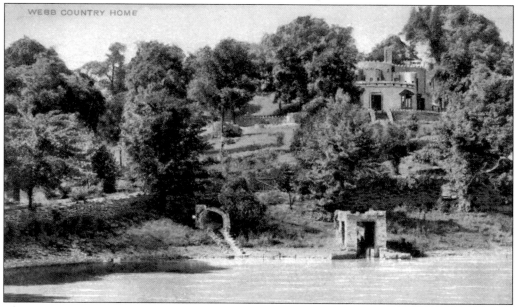

The Watt Webb castle was located on Truman Road opposite the entrance to Mount Washington Cemetery. It was designed as a replica of a Rhineland castle and built out of native fieldstone in 1893. Webb, founder of the Missouri Savings Bank, bought the 13-room castle in 1898, when the grounds covered more than 30 acres and had a stone carriage house, lake, and moat. The castle was razed after a 1977 fire. (Bill Latta.)

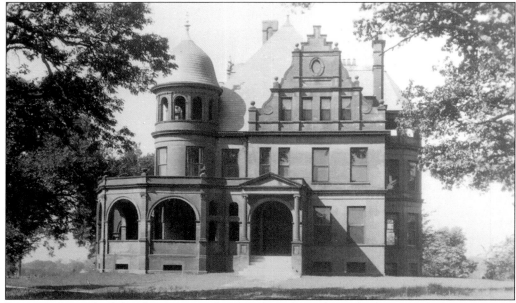

Logan O. Swope had this three-story redbrick and sandstone home built on South Pleasant Street in 1880. The home, seen in this 1928 photograph, had 26 rooms, turrets, towers, a ballroom, an elevator, and 19 acres of land. In 1909, three members of the family died mysteriously, including Col. Thomas Swope, who had given the land for Swope Park to Kansas City in 1896. The home was sold in 1923 to the RLDS church. It was razed in 1960. (Mary Charlotte Gamel.)

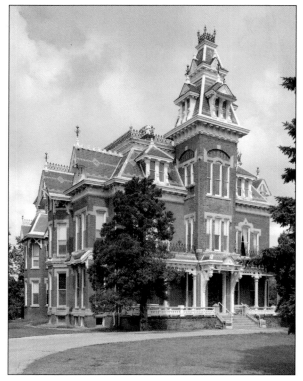

Harvey Merrick Vaile spent considerably more than $100,000 to build this 30-room mansion on North Liberty Street in 1881. The residence is so outstanding that *Architect* magazine has rated it as one of the finest examples of Second Empire Victorian architecture in America. The home had nine marble fireplaces, spectacular ceilings, flushing toilets, a 6,000-gallon water tank, and a massive wine cellar. (Library of Congress, Prints and Photographs Division.)

In 1904, the Allen brothers basketball team, from left to right, included Harry, Forrest (Phog), Homer, little Homer Jr., Elmer, Hubert, and Richard. Forrest played for the Kansas City Athletic Club 1904–1905 national championship team and coached the William Chrisman High School football and basketball teams during 1905 and 1906. He went on to coach basketball at the University of Kansas for 42 years. The university's basketball field house was named in his honor. (Harry S. Truman Library.)

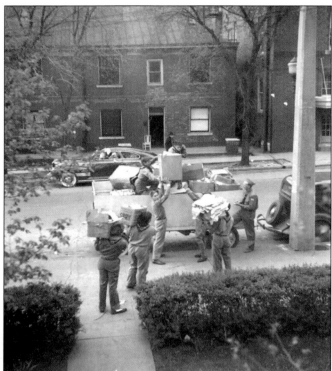

The first Boy Scout troop in Independence was organized in 1910 by W. O. Hands, a Sunday school teacher at the RLDS Stone Church. Scouting was a popular activity for many boys and was supported by many prominent business leaders and members of the community. This image shows seven members of Troop 228 and their scoutmaster during a scrap-paper drive during the 1940s. (Harry S. Truman Library.)

The Ace of Clubs semiprofessional baseball team was formed in 1929. The members of the team seen in this 1947 photograph, from left to right, are (first row) manager George Paresh, Phil Ratcliff, batboy Jimmie Ross, Bob Lyday, and captain Jim Lyday; (second row) Jack Hayde, Bud Conway, Elwyn Lewis, Tooner Waterfield, and Blackie White; (third row) business manager Arch Moran, Randy Rauh, Maurice Ritter, Mervin Fields, Larry Fields, and Jim Conway. (Independence Chamber of Commerce.)

Comin' Round the Mountain was called "the hillbilly howler of the year" when it was showing at the Granada Theater at 325 West Maple Street in 1941. Up to 600 moviegoers could have seen Bob Burns, Una Merkel, Jerry Colonna, Cliff Arquette, Don Wilson, and Harold Peary making his film debut as the Great Gildersleeves. Other movie houses in town included the Electric Theater on Main Street and the Plaza Theater on Lexington Street. (Phil Weeks family collection.)

The Rockwood Country Club, located between Hardy and Maywood Avenues south of Twenty-third Street, began with a nine-hole golf course in 1946. The club added a swimming pool, nine additional holes to the golf course, and this fine clubhouse, pro shop, and restaurant with banquet facilities. The clubhouse was razed in 1999, when new owners purchased the property. (Phil K. Weeks family collection.)

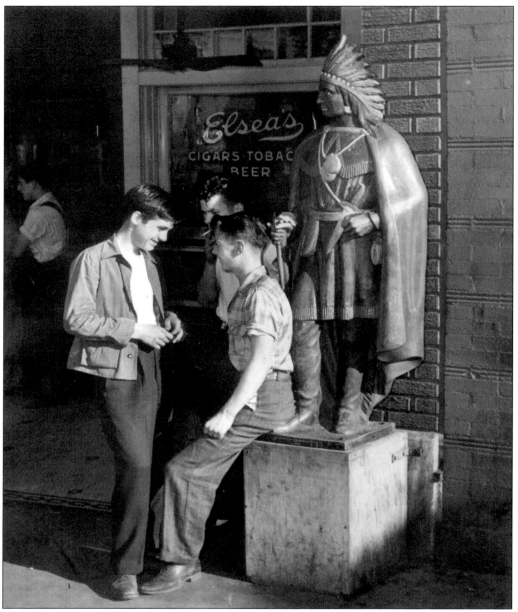

This pewter cigar store Indian named Minnehaha stood outside the Bodge Tobacco Shop on the south side of the town square for more than 40 years. No one knows for sure when he arrived, but his presence is documented to at least 1895. In this 1945 photograph, three young boys chat and smoke outside Elsea's cigar store on Lexington Avenue. (Harry S. Truman Library.)

Attorney Paul E. Anway is seen at his amateur radio broadcasting station in his home on Truman Road in the Maywood area. Anway was one of the founders of the Central Radio School in 1920, which developed into the KLDS broadcasting service for the RLDS church. In 1928, the church sold its radio service to KMBC of the Midland Broadcasting Company. (Diane Baldwin.)

William Rufus Wilson and his assistant, Ralph Organ, perform "Wilson's Modern Wonder Show" in the memorial building on Maple Street for Independence Junior High School students in 1949. The program, held in the stage-gymnasium room, featured high voltage, oscilloscopes, photoelectric cells, repelling magnets, black light, and other electrical demonstrations. (Diane Baldwin.)

Crysler Stadium was dedicated in 1941 during ceremonies that included famous Major League Baseball players and former William Chrisman High School students Morton Cooper and Walter Cooper. This photograph shows teams sponsored by Latimore Motors and Sitlington Insurance playing a game during 1951. The batter is Joe Klein. (Joe Klein.)

Professional Betty Layden gives a bowling lesson to an unidentified woman at Strike 'n Spare Bowl located on New Highway 40 in 1961. The popular 16-lane center opened in 1957 and was owned and operated by Bob Gall and Dennis Taylor. Bowlers enjoyed state-of-the-art Brunswick Crown Imperial equipment, a snack bar, a nursery and playroom, and 50¢-per-line bowling. (Joe Gall.)

Bob Williams stands next to the super-modified race car he drove at the Olympic Stadium race track for Taylor Weld's Auto Service in 1963. Williams drove for several Independence area racing concerns, usually super-modified and super-sprint cars. Olympic Stadium was originally built as a baseball stadium in the 1930s but was converted to a dirt track in 1940. (Bob Williams.)

The Independence Scale Blazers, the local chapter of Sweet Adelines, traveled to Oklahoma City, Oklahoma, to compete in the 1962 Region 7 chorus competition. Choral groups from chapters in Missouri, Kansas, Arkansas, and Oklahoma took part in the competition. This photograph shows the Scale Blazers chorus that won the regional title and their director Don Webb preparing for their performance. (Marietta Wilson Boenker.)

The Cool Crest miniature golf and swimming pool complex on Highway 40 near the Blue Ridge Mall was built, owned, and operated by King Patterson during the 1950s and 1960s. The first Miss Cool Crest beauty contest was held in 1961. From left to right, the contest finalists are unidentified, unidentified, Connie Commer, Marietta Wilson, and Brenda Shaw. (Marietta Wilson Boenker.)

Eight

THE MAN FROM INDEPENDENCE

Harry S. Truman became president of the United States at one of the most difficult periods of American history. Even though there was controversy in his presidency, he more than met the enormous challenges and made extremely difficult decisions with integrity, courage, and principle because he was well prepared for the job.

Harry was a product of hardy farming stock and frontier traditions. He was born in Lamar, Missouri, on May 8, 1884, to John and Martha Truman and grew up with a younger brother and sister on a 600-acre farm near Grandview, Missouri. The Truman family moved to Independence in 1890, and he attended the public schools, went to the First Presbyterian Church Sunday school where he met Bess Wallace, and held his first job working at the Clinton drugstore on the town square.

After graduation in 1901, Harry held a variety of jobs at the *Kansas City Star*; Atchison, Topeka and Santa Fe Railroad; and Kansas City banks before returning to Grandview to work the family farm from 1906 to 1917. His service in the Missouri National Guard enabled him to advance to command an army artillery battery in France during World War I.

Harry married Bess Wallace in 1919. He started a men's clothing store in Kansas City with his partner, Eddie Jacobson, in 1920. After the haberdashery failed, Harry successfully ran for judge from the eastern district of Jackson County in 1922 and served as presiding judge from 1926 to 1934. While serving as judge, he worked to get bonds passed to build a $400,000 hospital wing at the county home for the aged, $10 million for building new county roads, and $5 million for a new courthouse in Independence. He also played an important role in acquiring and improving several county parks, including Adair Park, Hill Park, and Hayes Park in Sibley.

In 1934, Harry was elected to the U.S. Senate, where he served until being elected vice president in 1944. He became president upon the death of Franklin D. Roosevelt in 1945 and was elected to another term from 1948 to 1952. He was president for 2,841 days.

Harry and Bess returned to Independence in 1953. Harry worked to raise the funds needed to build his presidential library and contributed his time and energy to several local organizations and youth groups. He died in 1972, and Bess passed away in 1982. They were buried side by side in a courtyard at the Harry S. Truman Library.

Harry S. Truman and his first-grade classmates stand on the steps of South Side School in 1892. Truman, who remembered his first year in school as a happy one, is at the extreme left of the front row. Teacher Mira Ewing is standing in the doorway behind her class of 37 students. By 1895, the school's name was changed to Noland School in honor of Hinton H. Noland, who had served on the school board from 1879 to 1894. (Harry S. Truman Library.)

Truman, seen here at the age of 13 in 1897, was an avid reader who began his lifelong reading habit during a long convalescence from diphtheria when he was nine years old. Late in life, he concluded that "readers of good books, particularly of biography and history, are preparing themselves for leadership. Not all readers become leaders. But all leaders must be readers." (Harry S. Truman Library.)

When Truman was 16 years old, he attended the 1900 Democratic National Convention in Kansas City with his father. He served as a convention page and watched the delegates nominate William Jennings Bryan and Adlai Stevenson to run against William McKinley and Theodore Roosevelt. The young Truman idolized Bryan as the voice of the common man. More than 50 years later, Truman worked to get Stevenson's grandson to be the Democratic Party's nominee for president in the 1952 general election. (Harry S. Truman Library.)

Truman was living in this house at 909 West Waldo Avenue when he graduated from high school. The home was his residence from 1895 to 1902. During these years, Truman learned to play the upright Kimball piano in the home's parlor, first with lessons from his mother then with additional instruction from a local teacher. When his skills advanced, he began twice-weekly piano lessons in Kansas City from Grace White, who studied under Theodore Leschetizky, a former teacher of Paderewski. (Harry S. Truman Library.)

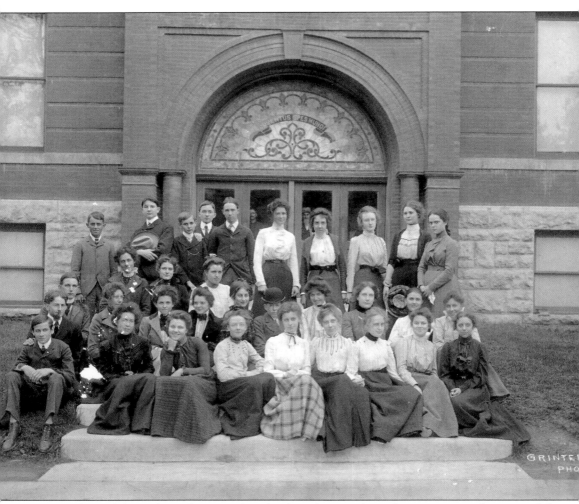

Members of the Independence High School graduating class of 1901 pose on the steps of the building's main entrance for a senior class portrait. Bess Wallace sits at the far right end of the second row, and Harry S. Truman is in the back row, fourth from the left end. In this picture, Truman is not wearing the eye glasses he needed to correct his farsightedness, which had been diagnosed in 1890. (Harry S. Truman Library.)

Wallace wears a long dress and gloves in this oval-shaped photograph taken at the time of her graduation from high school in 1901. Wallace and Truman attended school together from their fifth-grade year at Ott Elementary to high school graduation. Truman lost his heart to Wallace without any reciprocal feelings or encouragement from her. Wallace lived in a Victorian home, located at 608 North Delaware Street, when she graduated from Independence High School in 1901. The home was the Wallace family's residence from 1887 to 1903. It was less than three blocks away from Truman's house on West Waldo Avenue, and the young boy often walked past it on his way to school. Wallace moved to the Gates home at 219 North Delaware Street after her father's suicide in 1903. Truman began courting Wallace in 1910, and they became engaged in 1917. (Harry S. Truman Library.)

Bess Wallace (far right) sits in a balloon gondola during the 1911 Independence fair. From left to right, the other women are Mary Higgason Prewitt, Julia Rugg, and Anna Prewitt, Mary's daughter. Mary was the wife of Allen Prewitt, president of the Independence Fair Association and mayor of Independence from 1906 though 1908. (Harry S. Truman Library.)

Harry S. Truman sits behind the wheel of the second-hand 1911 Stafford touring car he bought for $650 in 1914. With him, from left to right, are Natalie Ott Wallace, Emma Southern, Frank Gates Wallace, and Bess. "Lizzie," as Truman called his right-hand drive car, was hand built in Kansas City and was one of only 300 Staffords ever made. Truman sold the car for $200 in 1918 just before he left for France and World War I. (Harry S. Truman Library.)

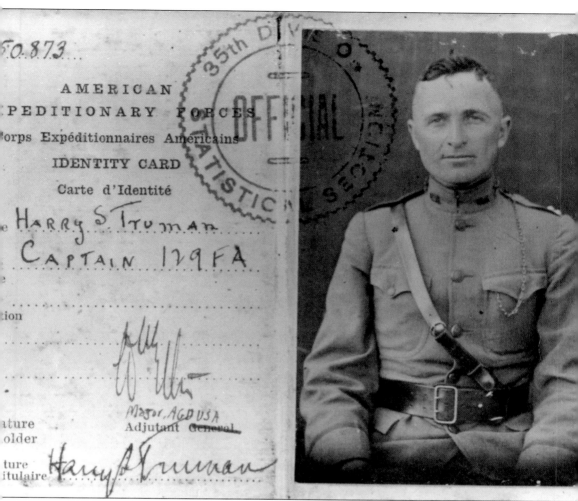

In 1917 at the age of 33, two years older than the age limit set by the national Selective Service Act, Truman rejoined the National Guard in which he had previously served from 1905 to 1911. He was given the rank of first lieutenant and sent to Camp Doniphan at Fort Sill in Lawton, Oklahoma. Truman arrived in Brest, France, on April 13, 1918, and was sent to an advanced artillery school for additional training on the French 75-millimeter gun, a rapid-fire cannon that played a major role in the war. After the training, Truman learned he had been promoted to captain in the 129th Field Artillery, 35th Division of the American Expeditionary Forces. On this identification card, Truman has a regulation military haircut but is not wearing his eyeglasses. Truman carried a portrait of Bess with him while serving in World War I. She had written on the back for him, "Dear Harry, may this photograph bring you safely home again from France." Truman also carried pictures of his mother and sister Mary Jane. (Harry S. Truman Library.)

Bess Wallace and Harry S. Truman were married at the Trinity Episcopal Church on June 28, 1919, less than eight weeks after Truman was discharged from the military. The members of the wedding party, seen here from left to right on the lawn of the Gates house at 219 North Delaware Street, are attendant Helen Wallace; best man Ted Marks; Truman; Frank Wallace, who escorted Bess to the altar; Bess; and attendant Louise Wells. (Harry S. Truman Library.)

The Truman and Jacobson Haberdashery store opened in November 1919 on West Twelfth Street opposite the Muehlebach Hotel in Kansas City. This view of the store's interior shows Truman (far left) with friends, from left to right, Francis Berry, Mike Flynn, and Kelsey Cravens. Truman and Eddie Jacobson had successfully managed the regimental canteen at Camp Doniphan in Oklahoma before they shipped out to France during World War I. Their men's furnishings store, however, was a dismal failure and closed in 1922. (Harry S. Truman Library.)

Mary Margaret Truman was born in the Truman home at 219 North Delaware Street on February 17, 1924. She was named after Mary Jane Truman, Harry's sister, and Madge Gates Wallace, Bess's mother. Margaret, who would be the Trumans' only child, was the center of attention for the Truman and Wallace households as well as the relatives living in the neighborhood. The baby's arrival was a blessed event for the couple, who had suffered greatly when Bess had miscarriages in 1920 and 1922. Bess holds her baby while sitting on the porch of the home on Delaware Street. (Harry S. Truman Library.)

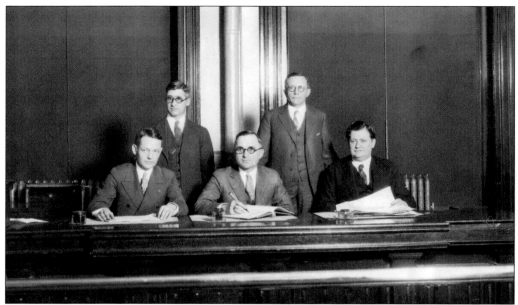

Harry S. Truman sits with his fellow Jackson County judges and clerks in 1927. From left to right are (first row) eastern district judge Robert W. Barr, presiding judge Truman, and western district judge Howard J. Vrooman; (second row) county deputy Edward G. Becker and county counselor Fred Boxley. Truman served as eastern district judge (1923–1924) and presiding judge (1926–1934) before being elected to the U.S. Senate. (Harry S. Truman Library.)

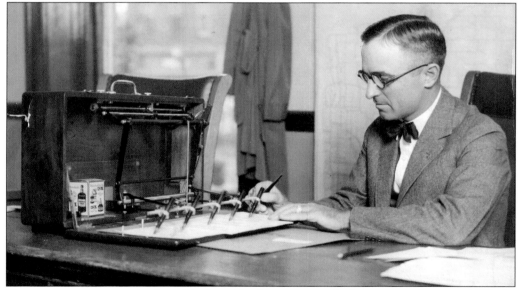

Truman signs county checks with the aid of a signature-duplicating machine in 1927. As Jackson County's chief executive officer, Truman was responsible for an annual operating budget of $7 million; more than 700 employees; two county courthouses; two jails; county services, including homes for the aged, boys, girls, black children, and a hospital; and the county's system of roads. He also appeared at a wide variety of meetings to extol the benefits of living in and doing business in Jackson County. (Harry S. Truman Library.)

The original small house at 219 North Delaware Street was purchased by George Porterfield Gates, Bess Truman's grandfather, in 1867. The Victorian home was greatly enlarged in 1885. In 1903, after her father committed suicide, Bess and her mother and brothers moved in with her grandparents. Bess lived in the 14-room house until she died in 1982, and Harry lived there from 1919 until his death in 1972. (Library of Congress, Prints and Photographs Division.)

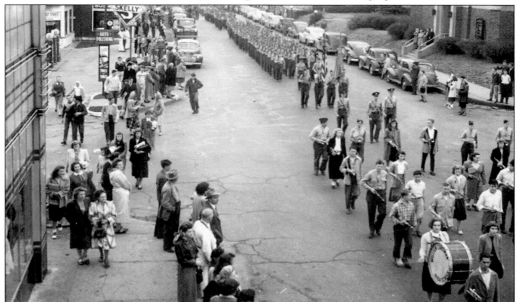

On November 2, 1948, Independence residents staged an Election Day parade in support of Truman. The parade route went east on Maple Street past the Soldiers and Sailors Memorial Building and the First Presbyterian Church to the town square and then west along Lexington Avenue. This photograph of the event shows the William Chrisman High School marching band and a military unit walking along the parade route. (Harry S. Truman Library.)

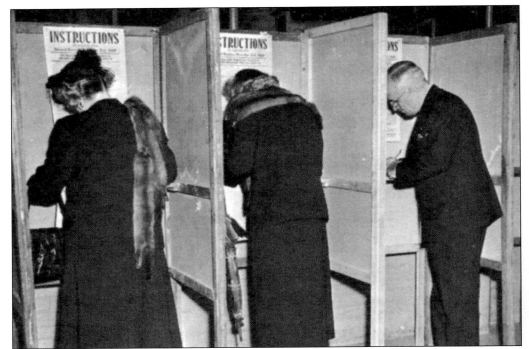

From left to right, this picture, taken in Independence's Memorial Building on November 2, 1948, shows the Truman family, Bess, Margaret, and Harry, voting on Election Day. (Harry S. Truman Library.)

The Douglas Aircraft Company delivered this airplane in 1947, and it served as Truman's plane until 1952. He named the Air Force C-118 the *Independence* after his hometown. The men on the tarmac are passengers and members of the flight crew, including the pilot, Lt. Col. Henry T. Myers; the copilot, Maj. Elmer F. Smith; and the navigator, Maj. T. J. Boselli. (Harry S. Truman Library.)

Truman was known for taking brisk walks every day, usually starting out at 7:00 a.m. regardless of the weather. He normally walked a mile or two each morning, moving quickly, at 120 paces per minute. In this photograph, Truman is being followed by a group of reporters and Secret Service men as he walks down the snow-packed sidewalk along Maple Street. The building in the background is Independence's Soldiers and Sailors Memorial Building. (Harry S. Truman Library.)

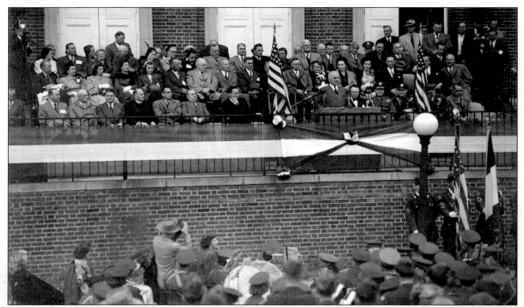

Pres. Harry S. Truman speaks in front of the Memorial Building during the dedication of an exact replica of the Liberty Bell on November 6, 1950. The 2,500-pound bell was presented to Independence by the people of Annecy-le-Vieux, France, as a token of friendship. It was housed in a gazebo outside the Memorial Building until 1959, when it was moved to the front lawn of the Harry S. Truman Library and Museum. (Harry S. Truman Library.)

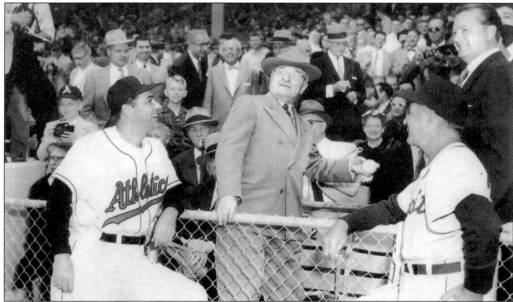

Former president Truman throws out the first ball at the first Kansas City Athletics baseball game ever played at Municipal Stadium on April 12, 1955. Lou Boudreau, the Athletics manager, is on the left, and Detroit Tiger manager Stanley "Bucky" Harris is on the right. The Athletics, who had moved to Kansas City from Philadelphia after the 1954 season, won the game 6-2 in front of a crowd of 32,844 fans. (Bill Latta.)

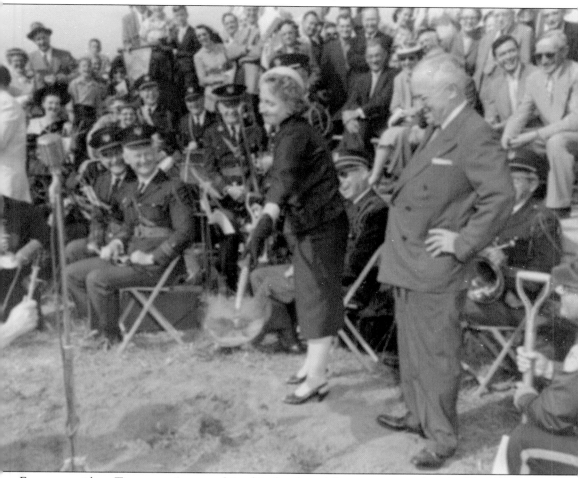

Former president Truman enjoys watching his daughter, Margaret, turn a shovel of dirt during the groundbreaking ceremony at the site of the future Harry S. Truman Library and Museum. The Independence Lions Club donated the gold-plated shovels for the May 8, 1955, event, and members of Local 34 of the American Federation of Musicians provided the music. The day was a special one for Truman for a second reason: it was his 71st birthday. The library, designed by local architects Alonzo H. Gentry and Edward Neild, was built in Slover Park on 13 acres of land donated by the City of Independence. The building cost $1.8 million, and Truman worked to raise every dollar needed for its construction from 17,000 contributions from people and organizations in every part of the country. The library was dedicated on July 6, 1957. (Harry S. Truman Library.)

The Truman and Daniel families stand by the staircase in the Truman home at 219 North Delaware Street in this photograph taken on Margaret Truman's wedding day, April 21, 1956. From left to right are Elbert Clifton Daniel, Elvah Jones Daniel, groom Clifton Daniel, Margaret, Bess Truman, and former president Harry S. Truman. The wedding took place in the Trinity Episcopal Church, the same church in which Harry and Bess were married in 1919. (Harry S. Truman Library.)

Former president Truman makes a telephone call to help the Jackson County Historical Society raise funds for the restoration of the old 1859 jail and marshal's home on Main Street in February 1959. Standing behind Truman, from left to right, are Phil K. Weeks, Frances Hink, and Phil C. Davis. (Harry S. Truman Library.)

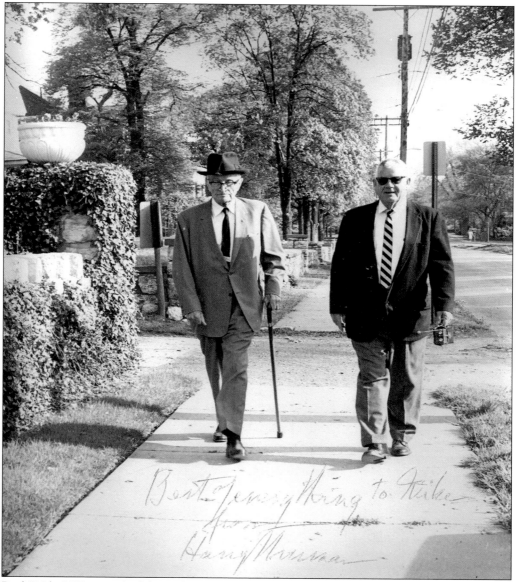

Paul "Mike" Westwood of the Independence Police Department (right) walks with a very aged former president Truman on a street near the Truman home. When Truman and his family returned home to Independence from Washington, D.C., on January 21, 1953, they were not given any protection by the Secret Service. The Independence Police Department assigned Westwood to be the former president's personal bodyguard. Westwood had been an occasional driver for Truman when he was a county judge. After Pres. John F. Kennedy was assassinated in 1963, the U.S. Congress authorized Secret Service protection of former presidents. Neither Harry nor Bess Truman wanted the Secret Service at their home and refused the protection, but Pres. Lyndon B. Johnson convinced them to accept it. Truman demanded that the Secret Service allow Westwood to remain on duty as his personal chauffeur and bodyguard. Westwood served as Truman's bodyguard for a total of 20 years, from 1953 to the president's death on December 26, 1972. (Independence Police Department.)

www.arcadiapublishing.com

Discover books about the town where you grew up, the cities where your friends and families live, the town where your parents met, or even that retirement spot you've been dreaming about. Our Web site provides history lovers with exclusive deals, advanced notification about new titles, e-mail alerts of author events, and much more.

MADE IN THE USA

Arcadia Publishing, the leading local history publisher in the United States, is committed to making history accessible and meaningful through publishing books that celebrate and preserve the heritage of America's people and places. Consistent with our mission to preserve history on a local level, this book was printed in South Carolina on American-made paper and manufactured entirely in the United States.

This book carries the accredited Forest Stewardship Council (FSC) label and is printed on 100 percent FSC-certified paper. Products carrying the FSC label are independently certified to assure consumers that they come from forests that are managed to meet the social, economic, and ecological needs of present and future generations.

FSC
Mixed Sources
Product group from well-managed forests and other controlled sources

Cert no. SW-COC-001530
www.fsc.org
© 1996 Forest Stewardship Council

Find Your Place in History.